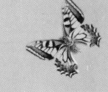

100

1 **DAMIEN HIRST, HYMN, 1999**
 painted bronze, 594.5 x 334 x 205.7cm
 (234.25 x 131.5 x 81in)

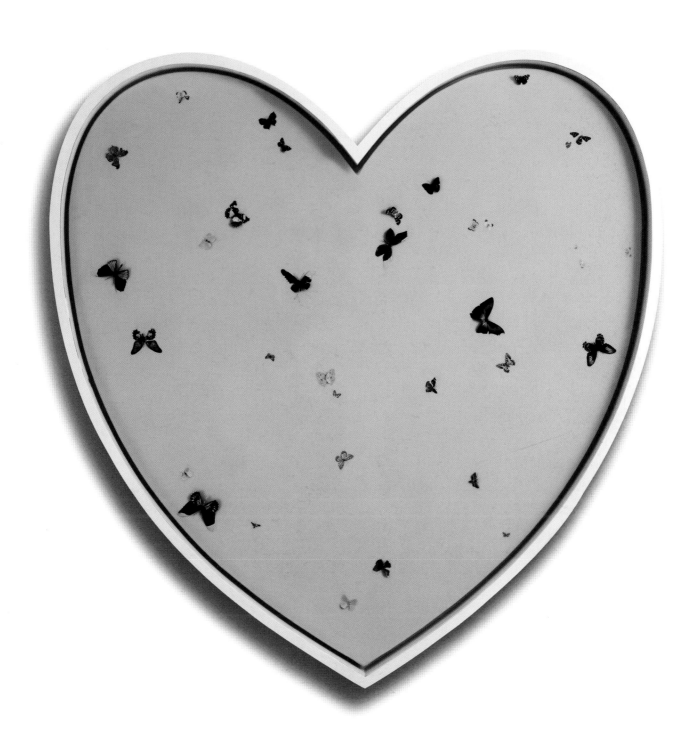

100

THE WORK THAT CHANGED BRITISH ART

INTRODUCTION BY CHARLES SAATCHI

TEXT BY PATRICIA ELLIS

JONATHAN CAPE, LONDON
IN ASSOCIATION WITH
THE SAATCHI GALLERY

CONTENTS

INTRODUCTION
CHARLES SAATCHI

It's not that 'Freeze', the 1988 exhibition that Damien Hirst organised with his fellow Goldsmiths College students, was particularly good. Much of the art was fairly so-so, and Hirst himself hadn't made anything much, just a cluster of colourful, small cardboard boxes placed high on a wall. Gary Hume's *Doors* and Mat Collishaw's *Bullet Hole* were the most immediate works in the two-part show. What really stood out was the hopeful swagger of it all.

Pretty soon, young artists got the message, stopped waiting for the call from Waddington or d'Offay and started organising their own shows. Abandoned warehouses, empty office buildings, disused shops, failed hair salons and ex-bookmakers across south and east London suddenly began filling with art that was headbuttingly impossible to ignore.

Most of the artists in this book first came to attention in shows like these and since then almost all of them have acquired swanky dealers in Britain, Europe and America.

The second wave of artists who emerged later in the nineties, followed that same route, and are included here because they are now galvanising students in Britain's art colleges where they have many admirers and 'schools of'.

Even if the majority of 'alternative' exhibitions are overwhelmingly lacklustre, when something special turns up it's easy to forget the get-a-life days trudging around dismal shows in your anorak – particularly if you believe that recent British art is pretty much the only art that will be worth more than a footnote in future chronicles of the late twentieth century. That something special – that sense of 'get off your easel, you've pulled' – is more than a gut reaction but is worlds away from arid intellectualising. Sometimes the work is groundbreaking, sometimes it's provocative, but it needs to be neither. If art can make you step into the world of the person who's made it and convince you of the clarity of the artist's imagination, it's doing plenty.

What is it about the life cycle of flies, someone's old bed, a portrait of a child killer made with children's handprints, mannequins with knobs on, someone sitting on a toilet holding a cistern, that makes British art so different, so appealing?

There's no neat link, no school, just a very direct, almost infantile energy that gives the work here its full-on, check-this-out force.

WAVE 1

3 DAMIEN HIRST,
 HOLIDAYS/NO FEELINGS, 1989
 drug bottles, cabinet,
 137 x 204 x 23cm
 (54 x 80 x 9in)

4 DAMIEN HIRST,
ARGININOSUCCINIC ACID, 1995
gloss household paint on canvas,
335 x 457.2cm (132 x 180in)

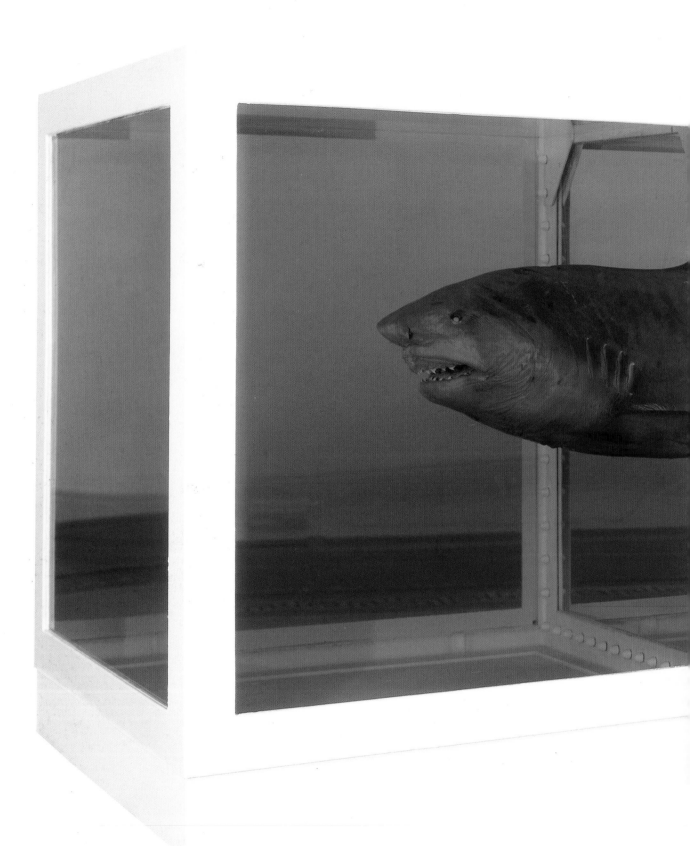

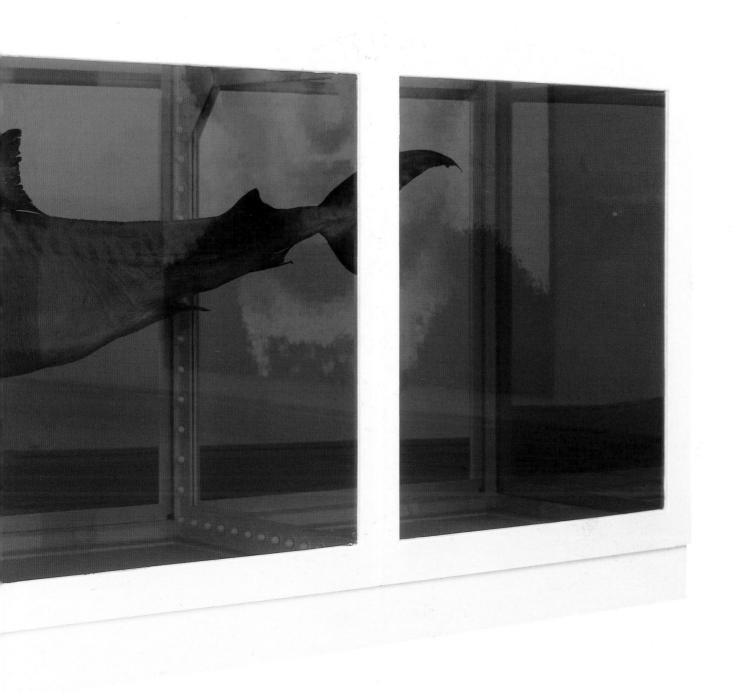

5 DAMIEN HIRST, THE PHYSICAL
IMPOSSIBILITY OF DEATH IN THE
MIND OF SOMEONE LIVING, 1991
tiger shark, glass, steel, 5% formaldehyde
solution, 213 x 518 x 213cm (84 x 204 x 84in)

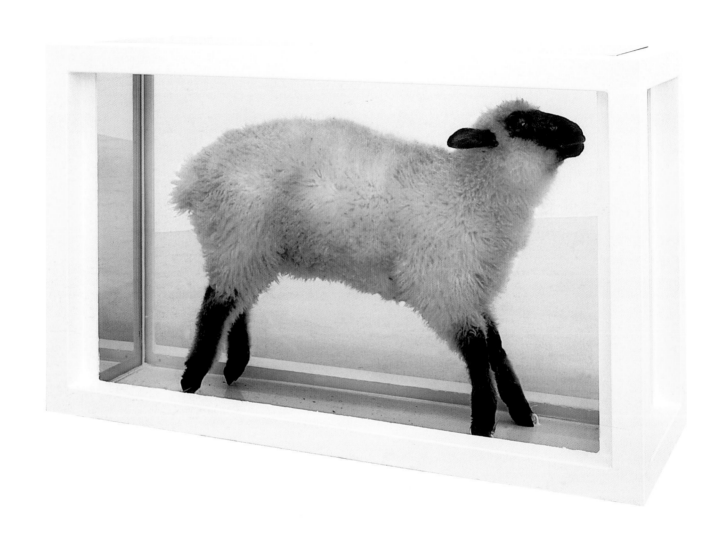

6 **DAMIEN HIRST,**
 AWAY FROM THE FLOCK, 1994
 lamb, glass, steel, formaldehyde solution,
 96.5 x 149 x 51cm (38 x 59 x 20in)

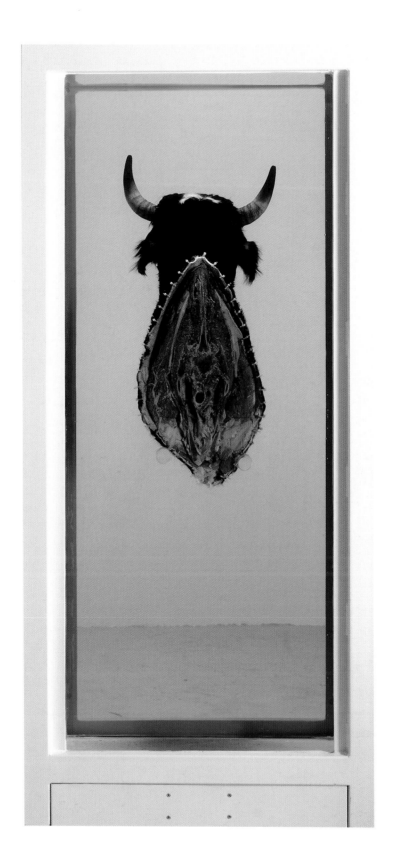

7 **DAMIEN HIRST, SOME COMFORT GAINED FROM THE ACCEPTANCE
OF THE INHERENT LIES IN EVERYTHING, 1996** (detail)
steel, glass, cows, formaldehyde solution, 12 tanks,
each 200 x 90 x 30cm (78.7 x 34.5 x 11.8in)

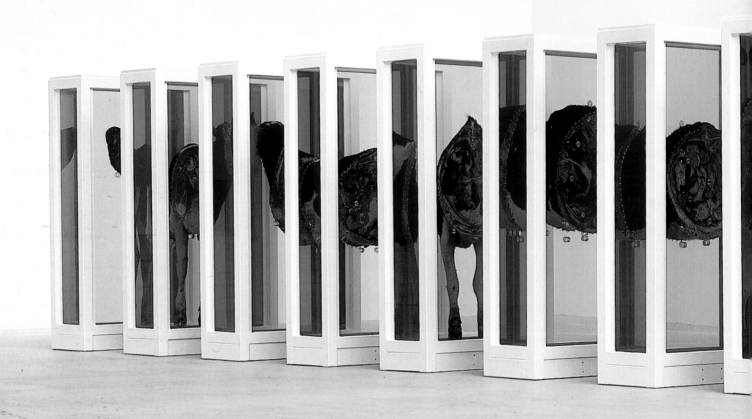

7 DAMIEN HIRST, SOME COMFORT GAINED
FROM THE ACCEPTANCE OF THE INHERENT
LIES IN EVERYTHING, 1996
steel, glass, cows, formaldehyde solution, 12 tanks,
each 200 x 90 x 30cm (78.7 x 34.5 x 11.8in)

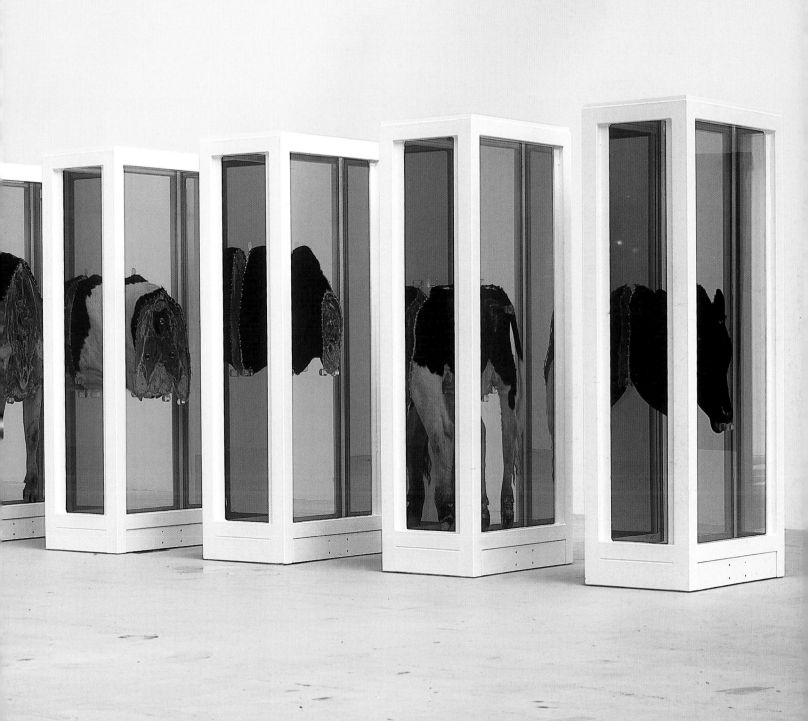

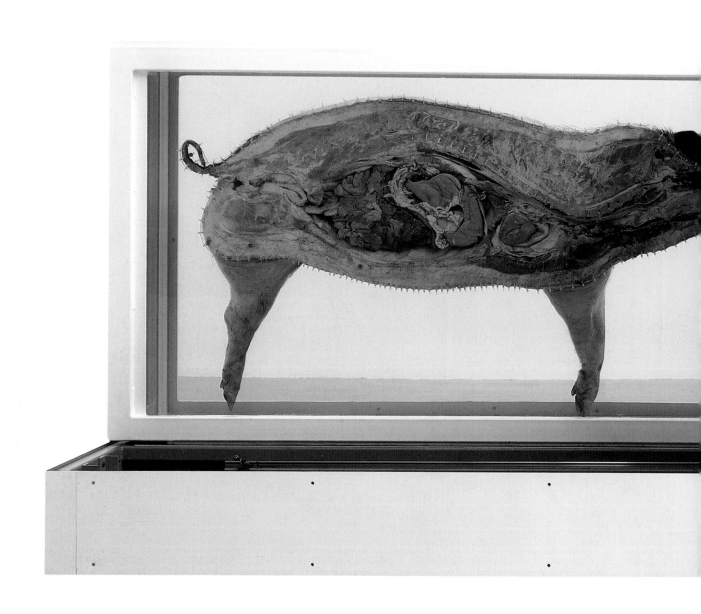

8 DAMIEN HIRST, **THIS LITTLE PIGGY WENT TO MARKET, THIS LITTLE PIGGY STAYED HOME, 1996**
steel, GRP composites, glass, pig, formaldehyde solution,
electric motor (tanks move backwards and forwards),
two tanks, each 120 x 210 x 60cm (47.3 x 82.7 x 23.6in)

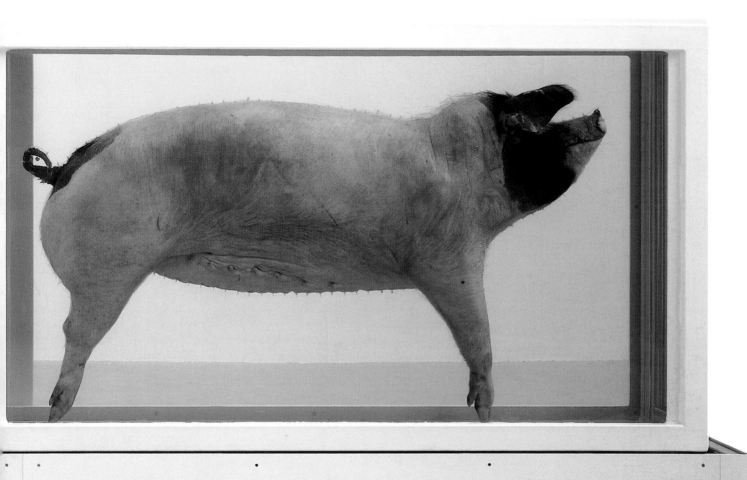

9 DAMIEN HIRST, ISOLATED ELEMENTS
SWIMMING IN THE SAME DIRECTION FOR
THE PURPOSE OF UNDERSTANDING, 1991
MDF, melamine, wood, steel, glass, perspex cases,
fish, 5% formaldehyde solution, 183 x 274 x 30.5cm
(72 x 108 x 12in)

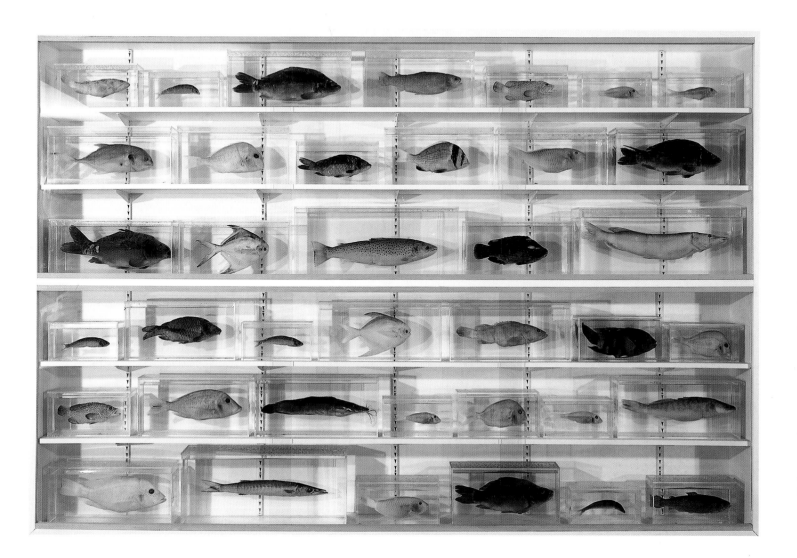

10 DAMIEN HIRST, LOVE LOST, 2000
vitrine tank and filtration unit, couch, trolley,
chair, surgical instruments, computer, fish,
213.4 x 213.4 x 213.4cm (84 x 84 x 84in)

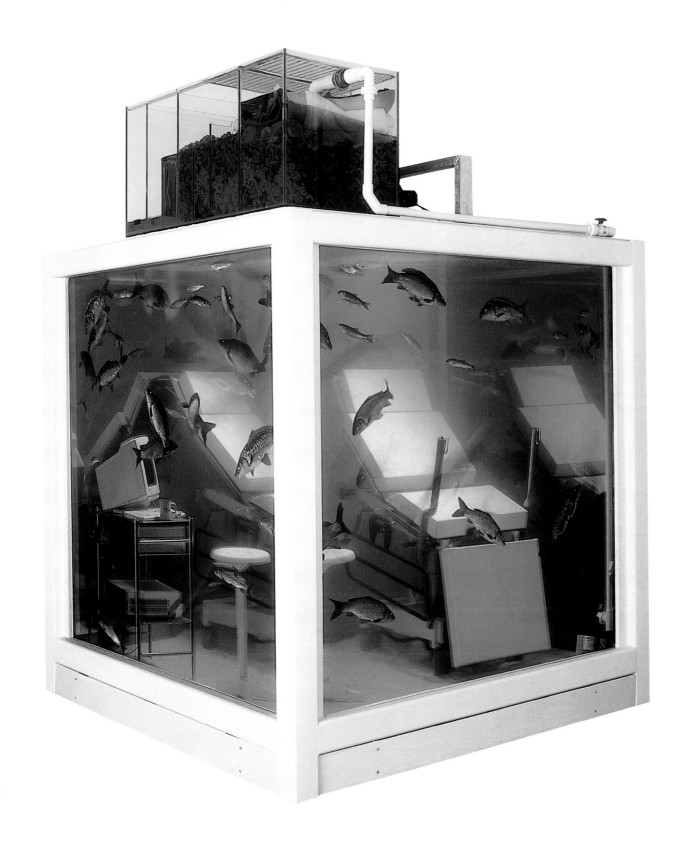

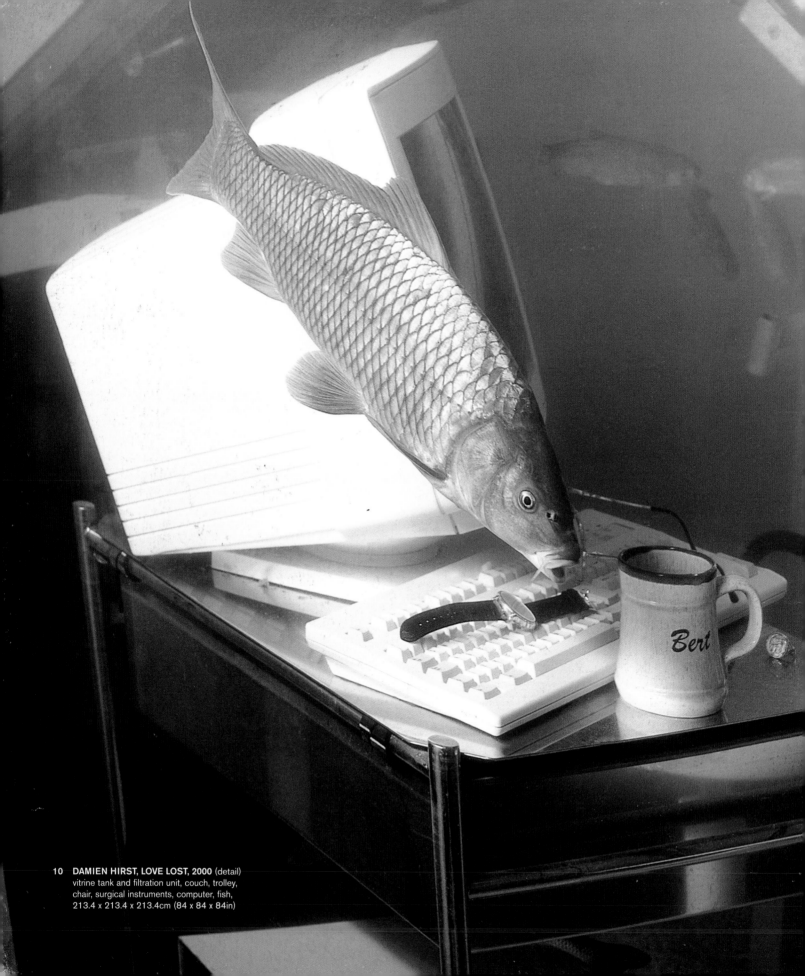

10 DAMIEN HIRST, LOVE LOST, 2000 (detail)
vitrine tank and filtration unit, couch, trolley,
chair, surgical instruments, computer, fish,
213.4 x 213.4 x 213.4cm (84 x 84 x 84in)

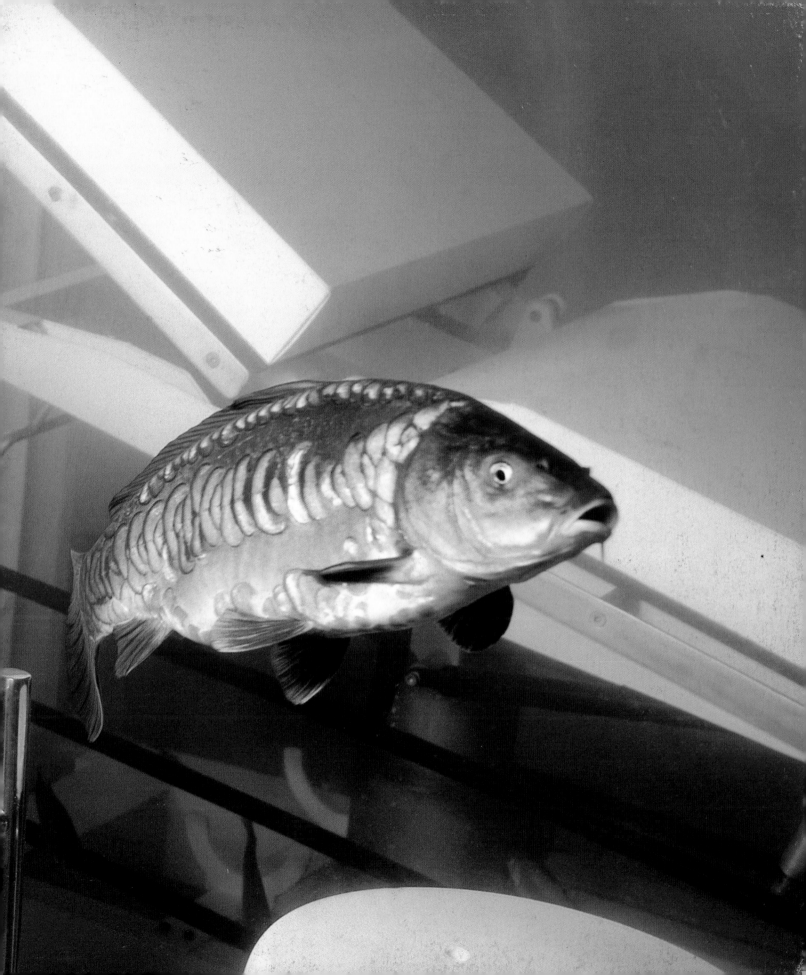

11 **JENNY SAVILLE, SHIFT, 1996–7**
 oil on canvas, 330 x 330cm (130 x 130in)

12 **JENNY SAVILLE, FULCRUM, 1999** (overleaf)
 oil on canvas, 261.6 x 487.7cm (103 x 193in)

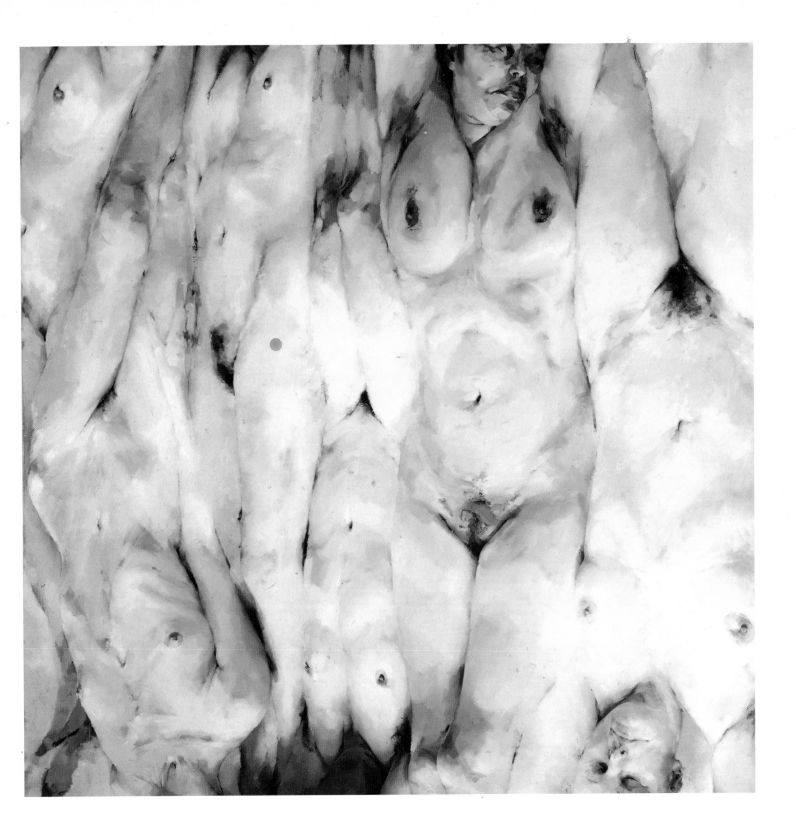

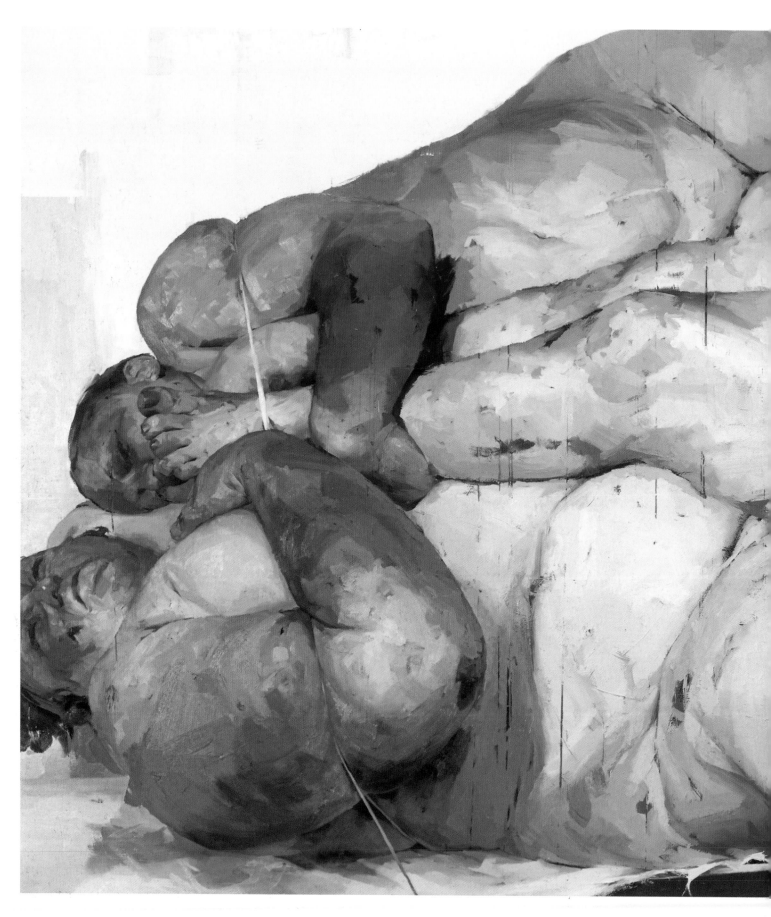

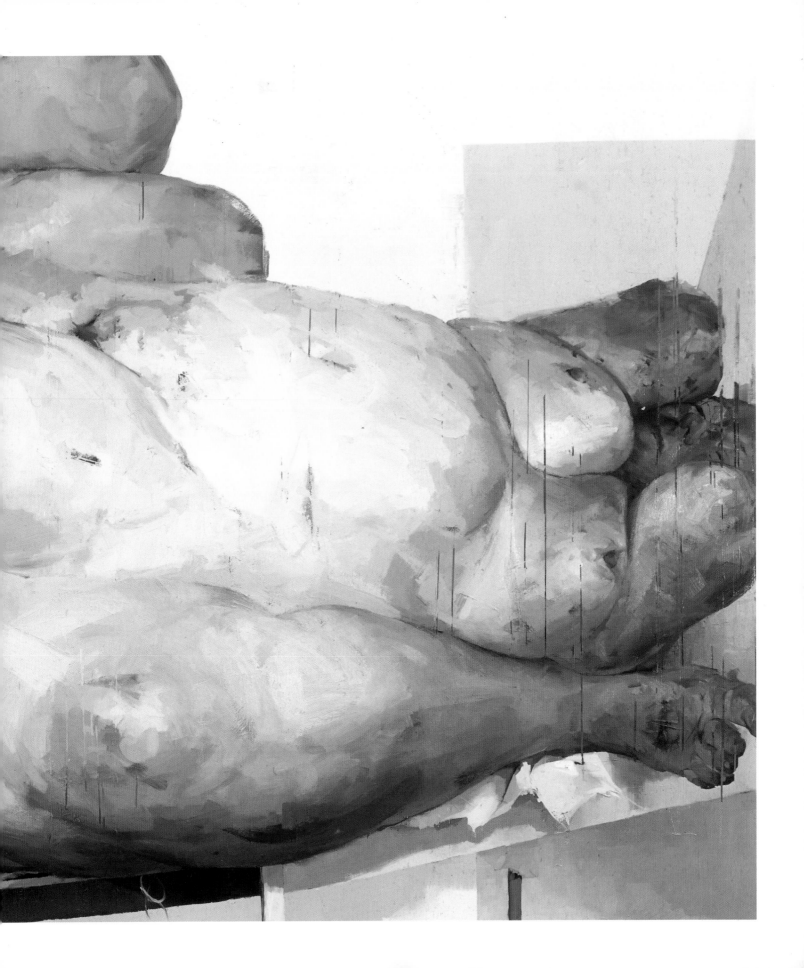

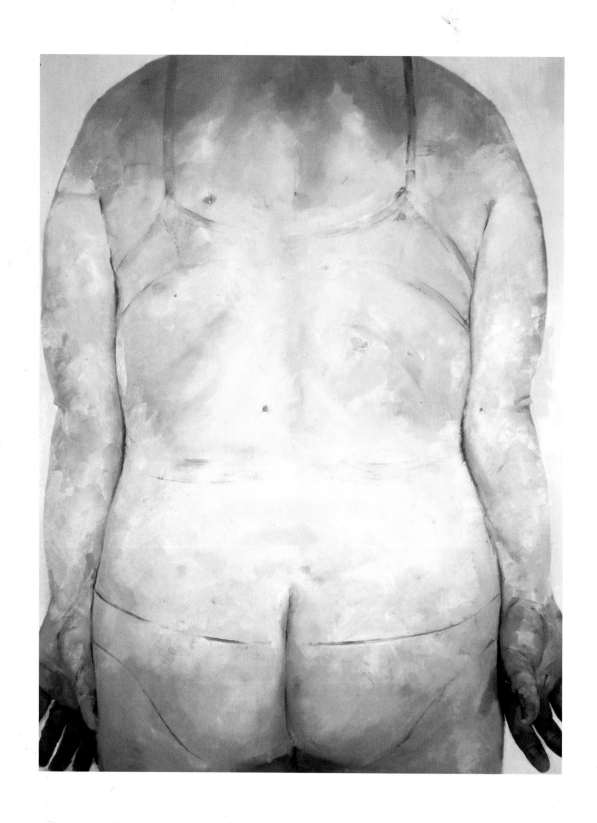

13 JENNY SAVILLE, TRACE, 1993–4
oil on canvas, 213.5 x 165cm (84 x 72in)

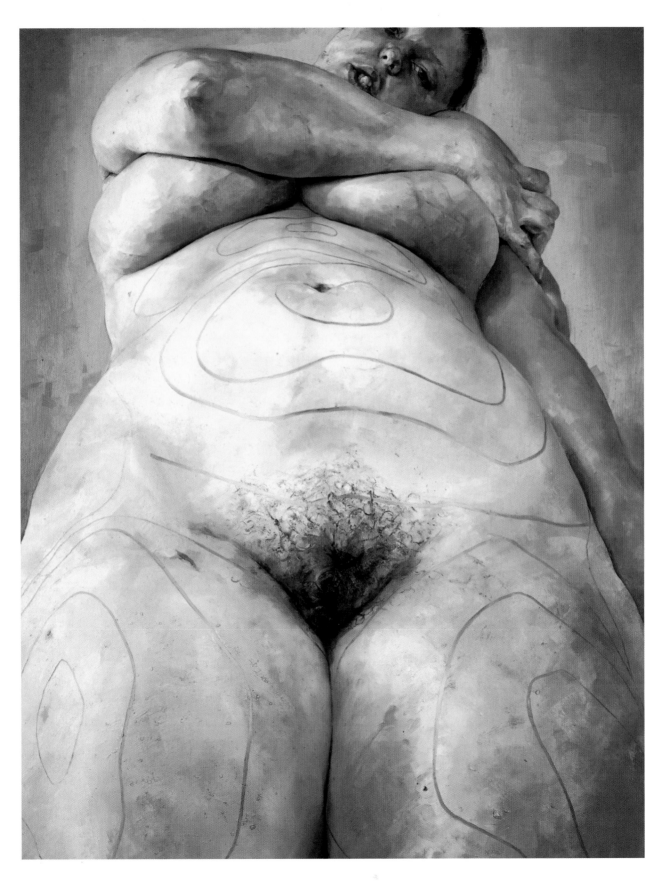

14 JENNY SAVILLE, PLAN, 1993
oil on canvas, 274 x 213.5cm (108 x 84in)

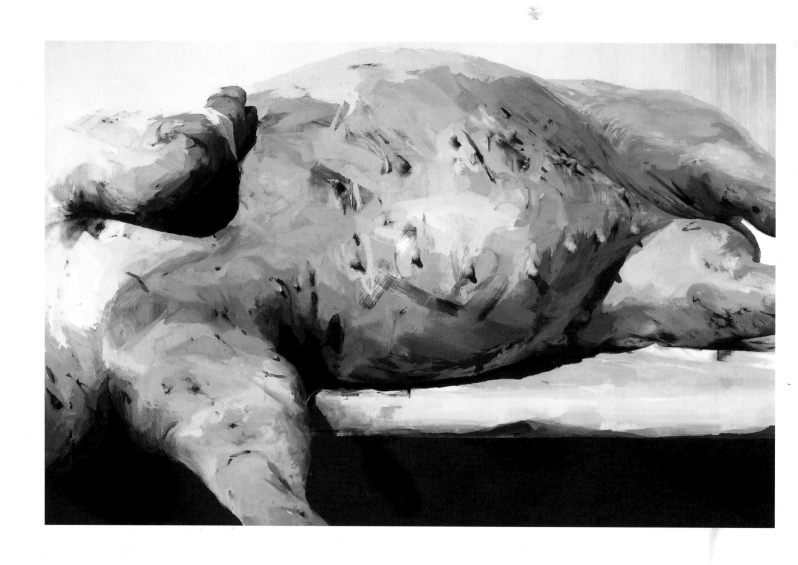

15 JENNY SAVILLE, HOST, 2000
oil on canvas, 304.8 x 457.2cm (120 x 180in)

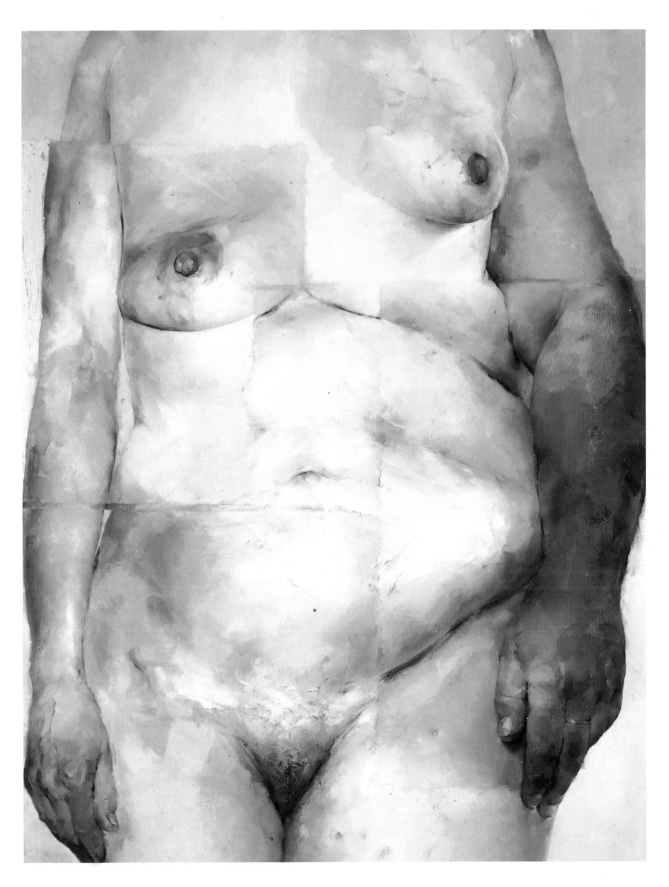

16 JENNY SAVILLE, HYBRID, 1997
oil on canvas, 274.3 x 213.4cm (108 x 84in)

17 **JENNY SAVILLE, PROPPED, 1992**
oil on canvas, 213.5 x 183cm (84 x 72in)

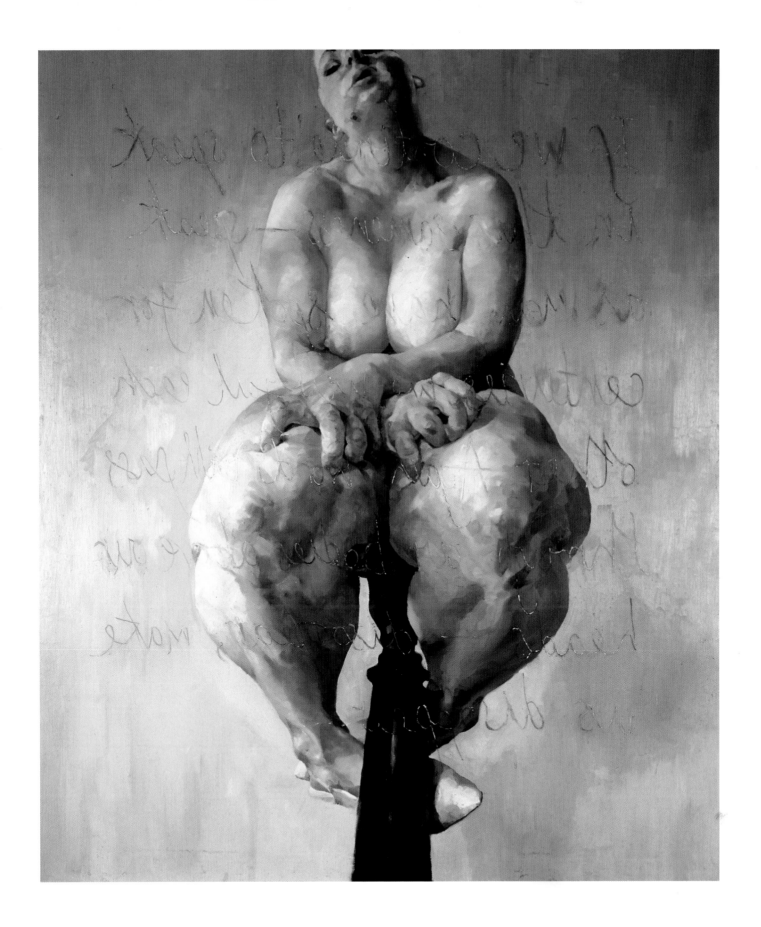

18 GLENN BROWN, DALI-CHRIST, 1992
oil on canvas, 274 x 183cm (108 x 72in)

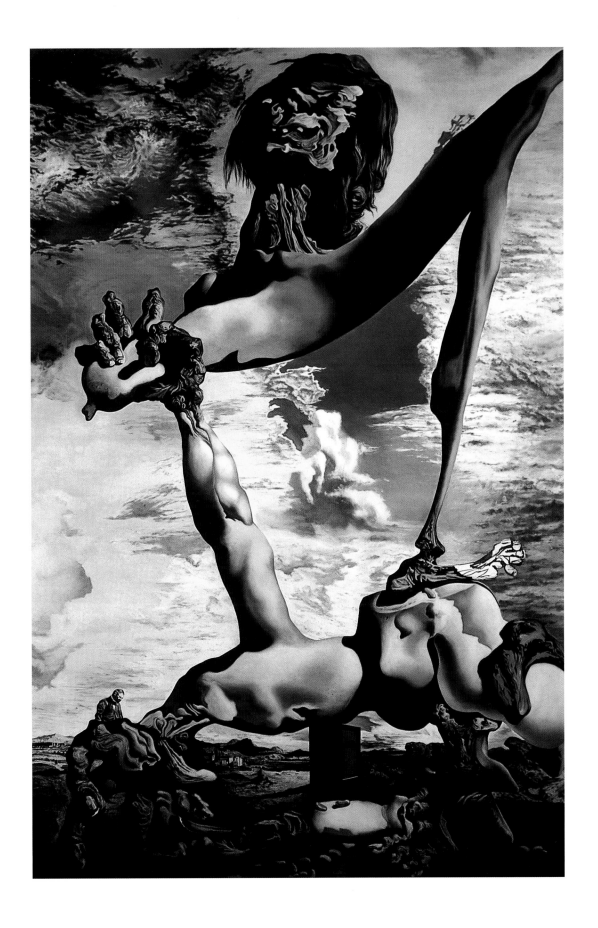

19 GLENN BROWN, ORNAMENTAL
 DESPAIR (PAINTING FOR IAN CURTIS)
 AFTER CHRIS FOSS, 1994
 oil on canvas, 201 x 300cm (79 x 118in)

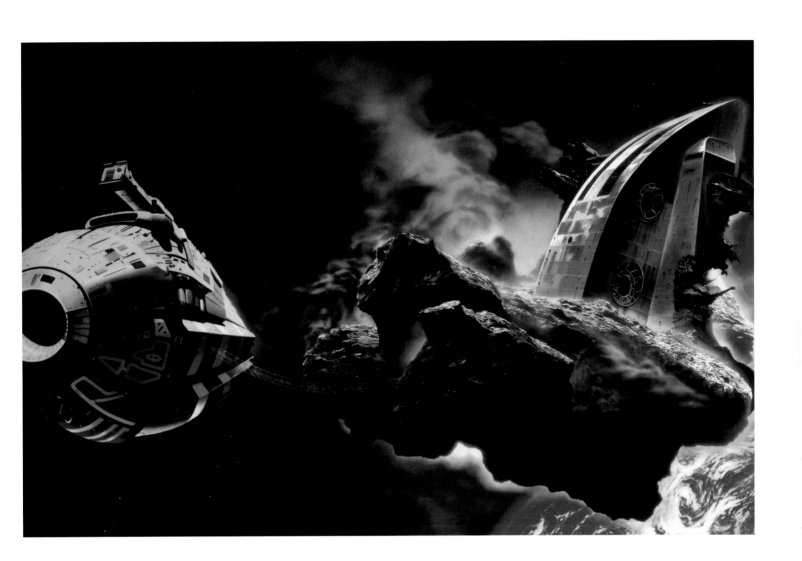

20 **JAKE AND DINOS CHAPMAN,**
 DNA ZYGOTIC, 1997
 fibreglass, resin and paint,
 190 x 90 x 90cm (74.8 x 35.5 x 35.5in),
 base 17 x 90 x 80cm (6.7 x 35.5 x 31.5in)

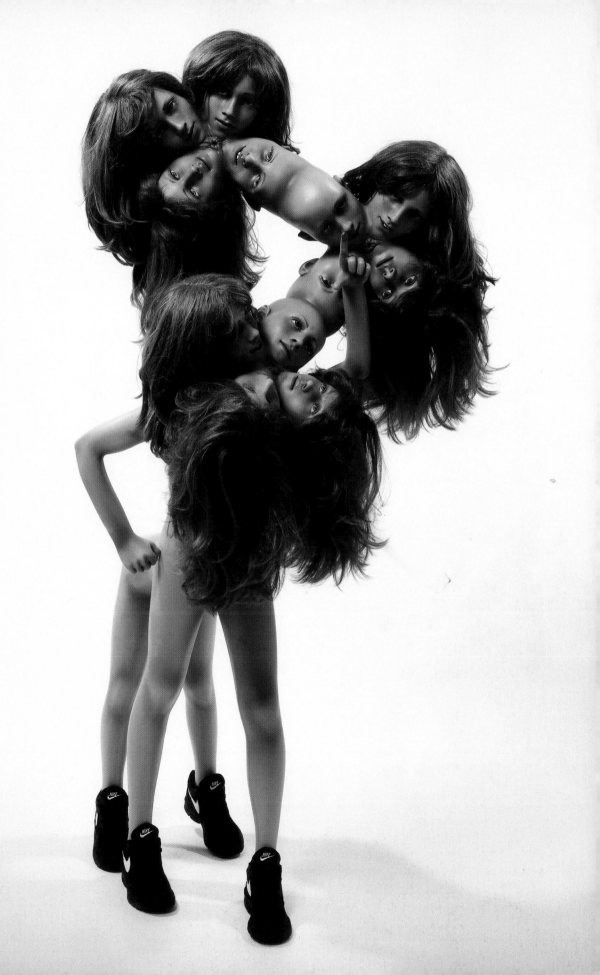

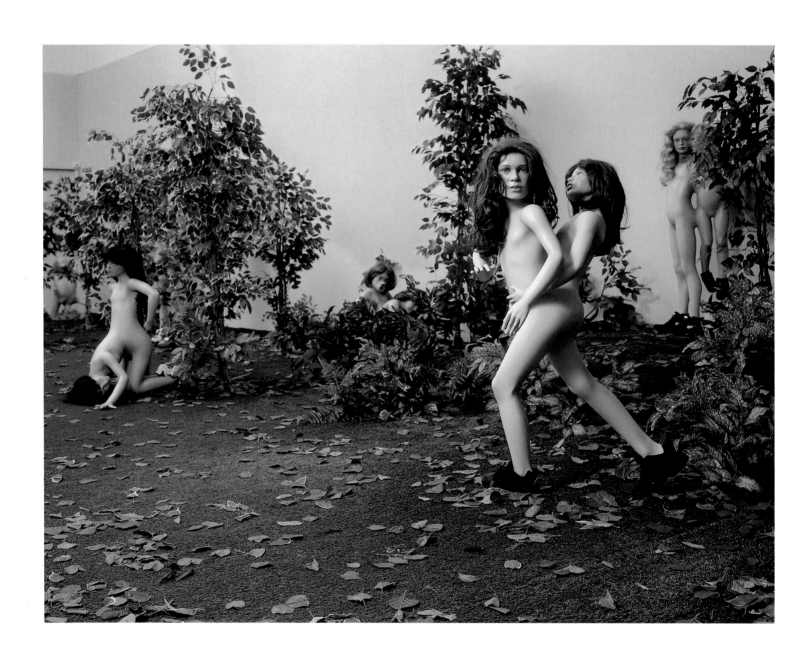

21 **JAKE AND DINOS CHAPMAN,
TRAGIC ANATOMIES, 1996**
fibreglass, resin, paint, smoke
devices, varied measurements

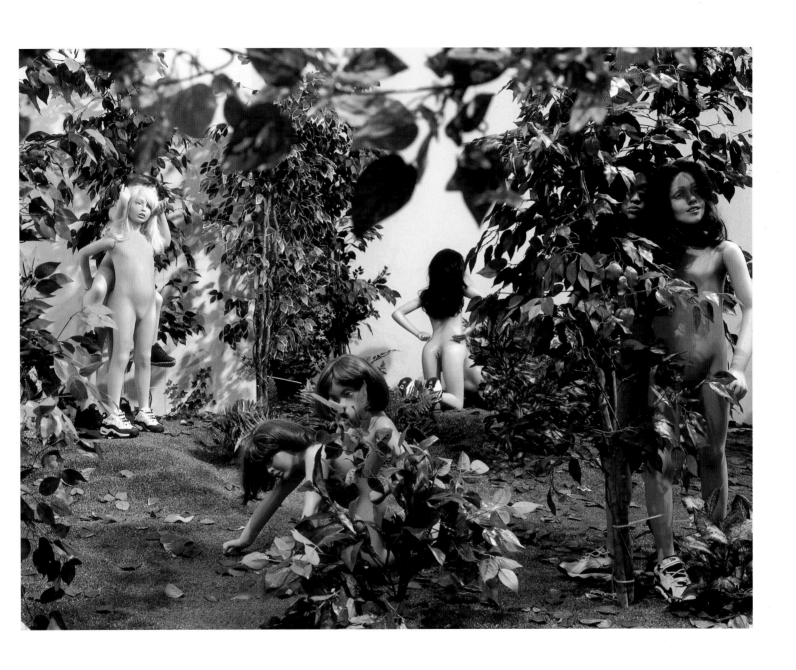

21 **JAKE AND DINOS CHAPMAN,**
TRAGIC ANATOMIES, 1996
fibreglass, resin, paint, smoke
devices, varied measurements

22 JAKE AND DINOS CHAPMAN,
ZYGOTIC ACCELERATION, BIOGENETIC,
DESUBLIMATED LIBIDINAL MODEL
(ENLARGED X 1000), 1995
fibreglass, 150 x 180 x 140cm (59 x 70.9 x 55in),
plinth 180 x 20 x 150cm (70.9 x 7.9 x 59in)

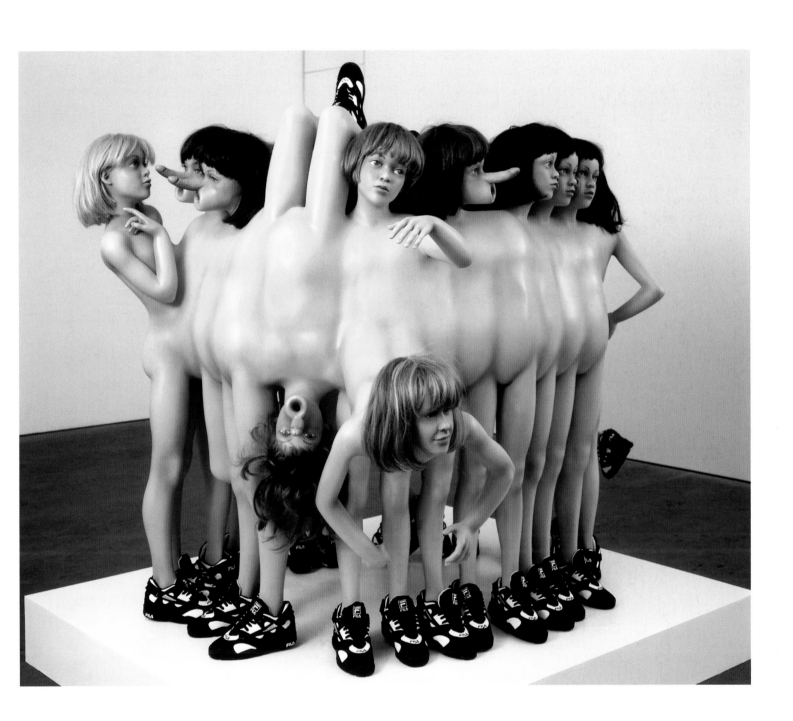

23 JAKE AND DINOS CHAPMAN,
GREAT DEEDS AGAINST THE DEAD, 1994
mixed media with plinth,
overall 277 x 244 x 152cm
(109 x 96 x 60in)

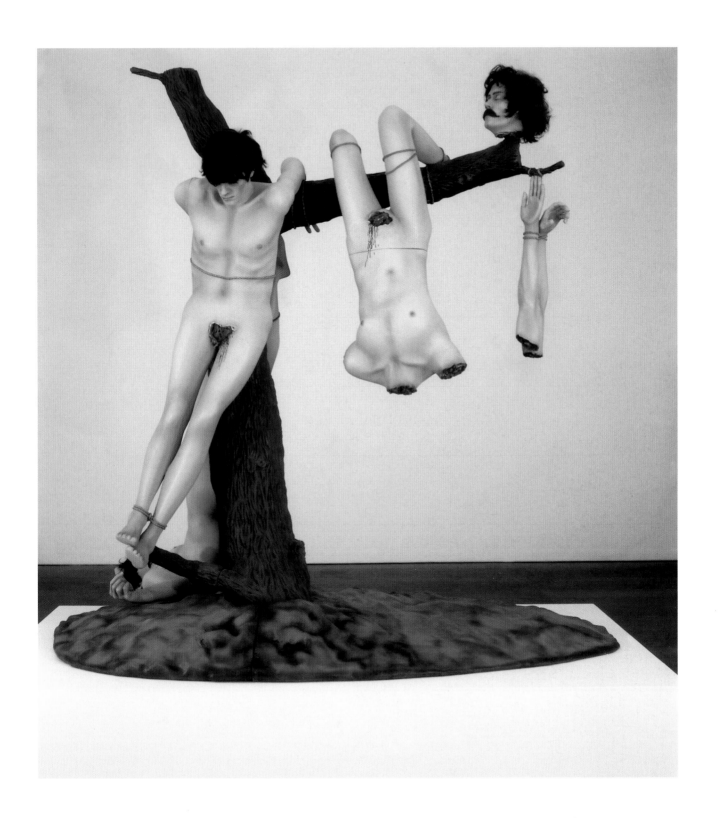

24 **JAKE AND DINOS CHAPMAN,**
DISASTERS OF WAR, 2000
83 hand-coloured etchings,
24.5 x 34.5cm (9.6 x 13.6in)

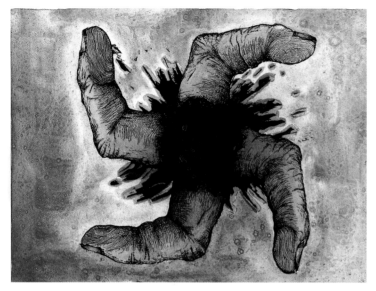

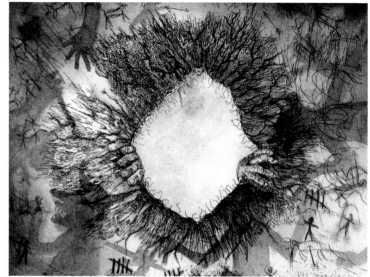

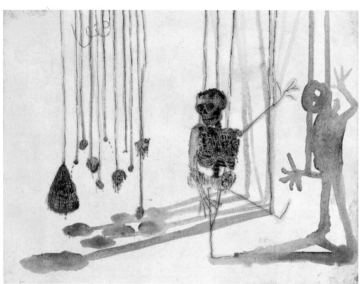

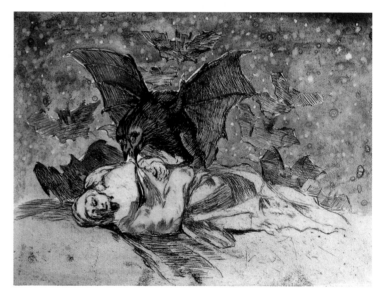

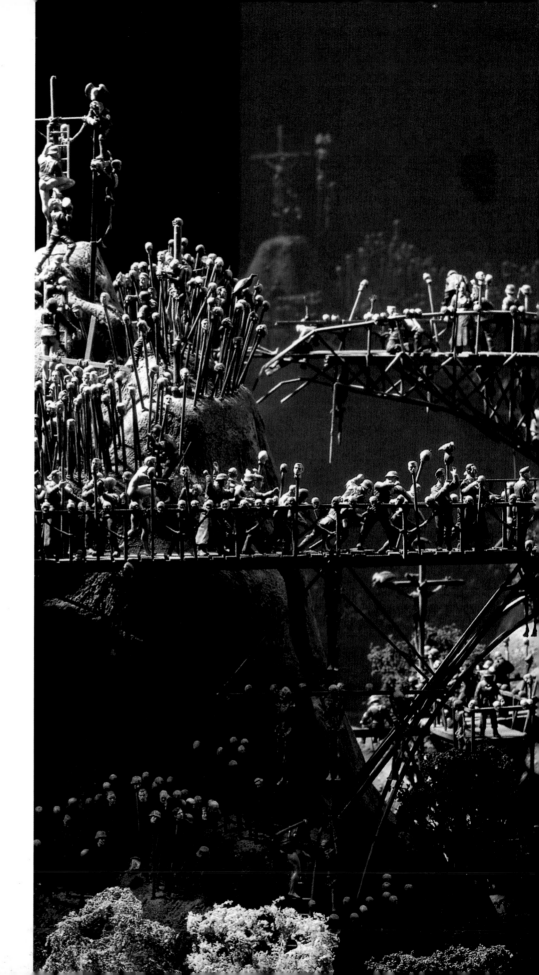

25 JAKE AND DINOS CHAPMAN,
HELL, 1998–2000 (detail)
fibreglass, plastic and mixed media (9 parts)
8 parts 243.8 x 121.9 x 121.9cm (96 x 48 x 48in)
1 part 121.9 x 121.9 x 121.9cm (48 x 48 x 48in)

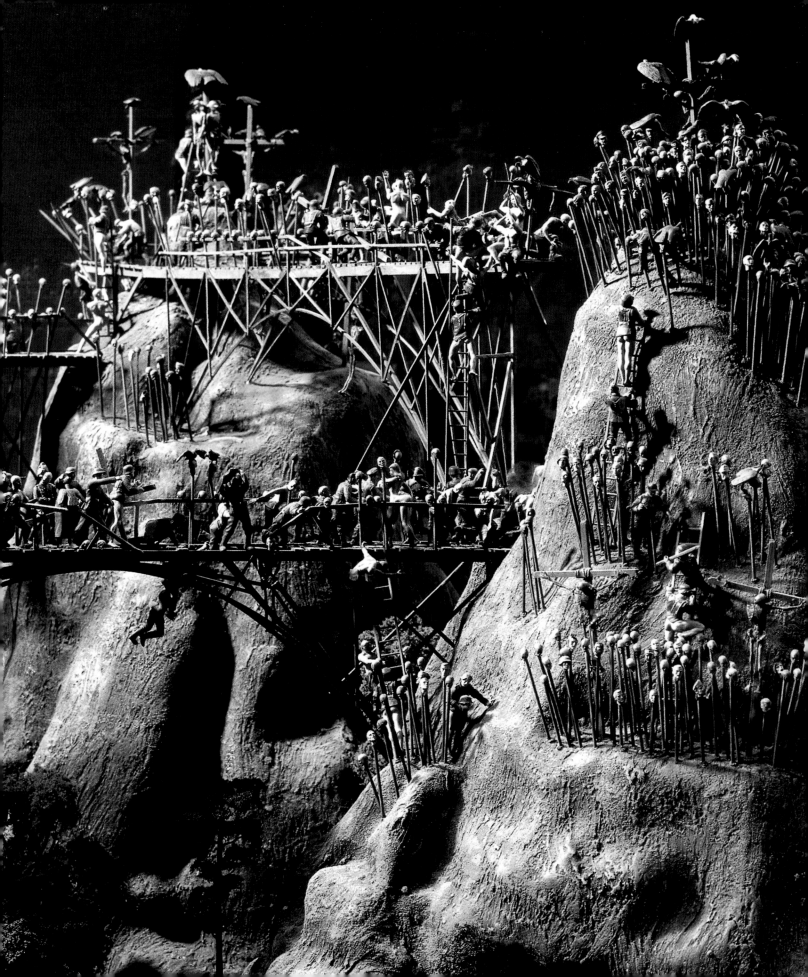

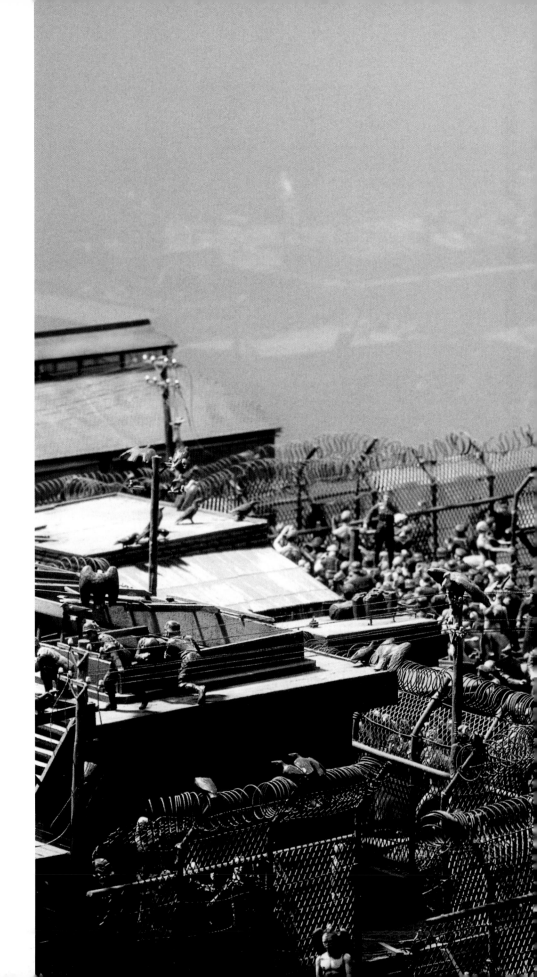

25 JAKE AND DINOS CHAPMAN,
 HELL, 1998–2000 (detail)
 fibreglass, plastic and mixed media (9 parts)
 8 parts 243.8 x 121.9 x 121.9cm (96 x 48 x 48in)
 1 part 121.9 x 121.9 x 121.9cm (48 x 48 x 48in)

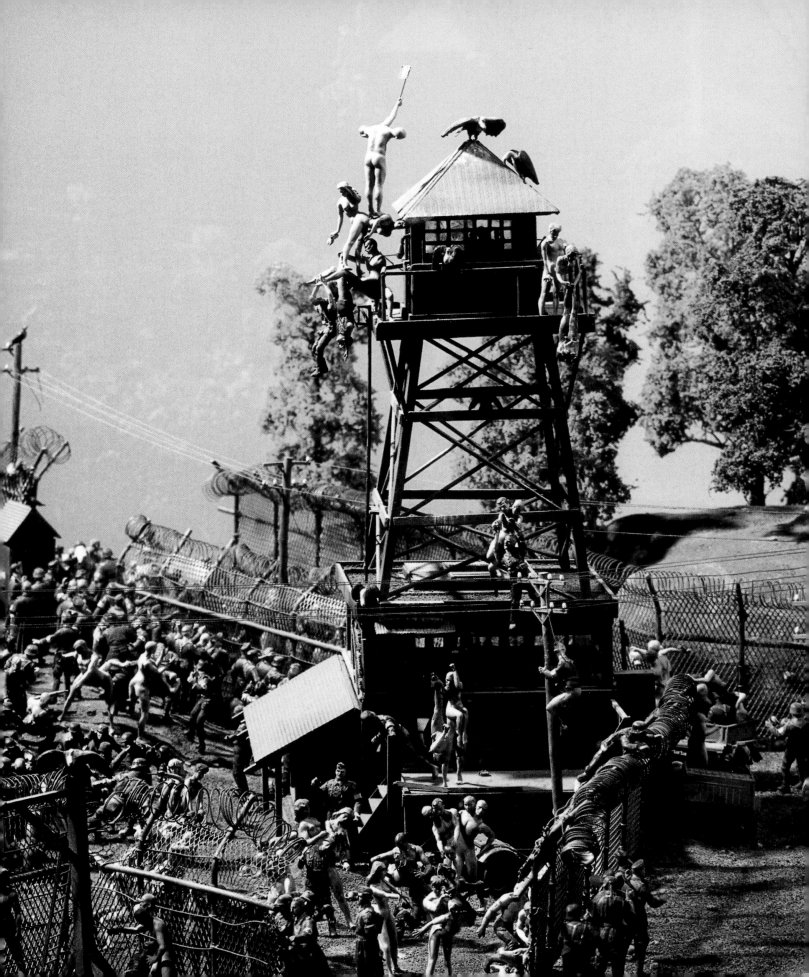

26 **JAKE AND DINOS CHAPMAN,**
 THE CHAPMAN FAMILY COLLECTION, 2002
 33 hand-carved wood works, wood,
 paint and mixed media

CFC74378524

CFC72322450

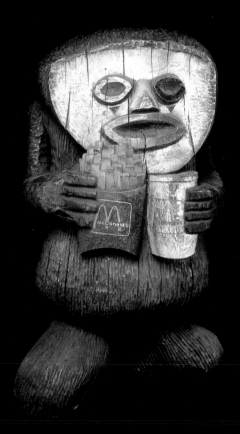

CFC76311561

CFC77227084

CFC772337192

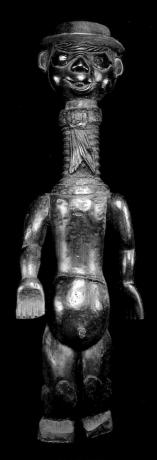

CFC72403096

CFC77135099

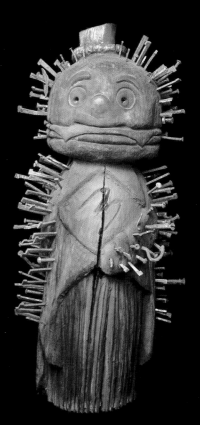

CFC77023115

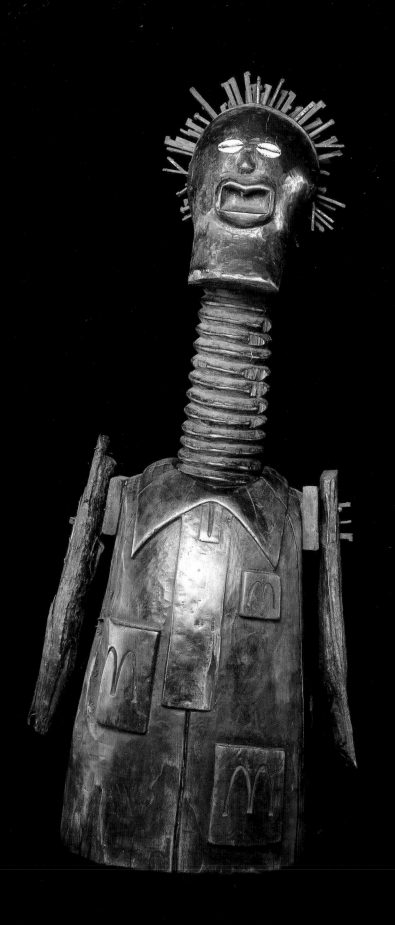

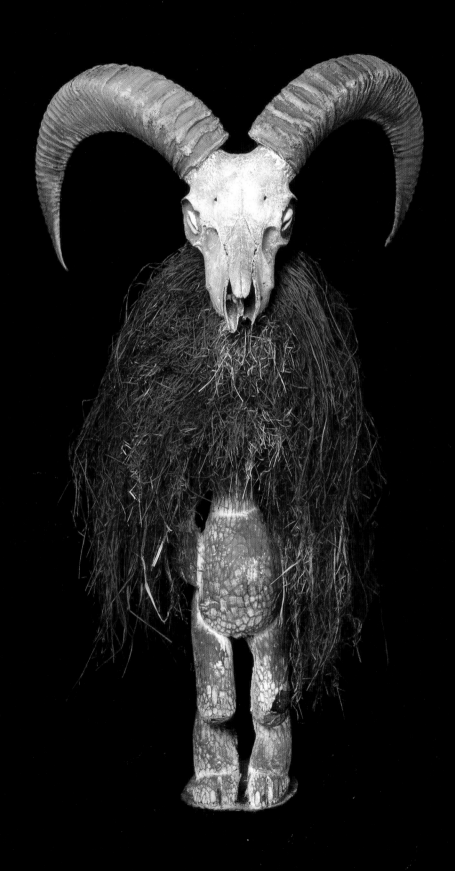

27 CHRIS OFILI,
THE HOLY VIRGIN MARY, 1996
paper collage, oil paint, glitter, polyester
resin, map pins, elephant dung on linen,
243.8 x 182.9cm (96 x 72in)

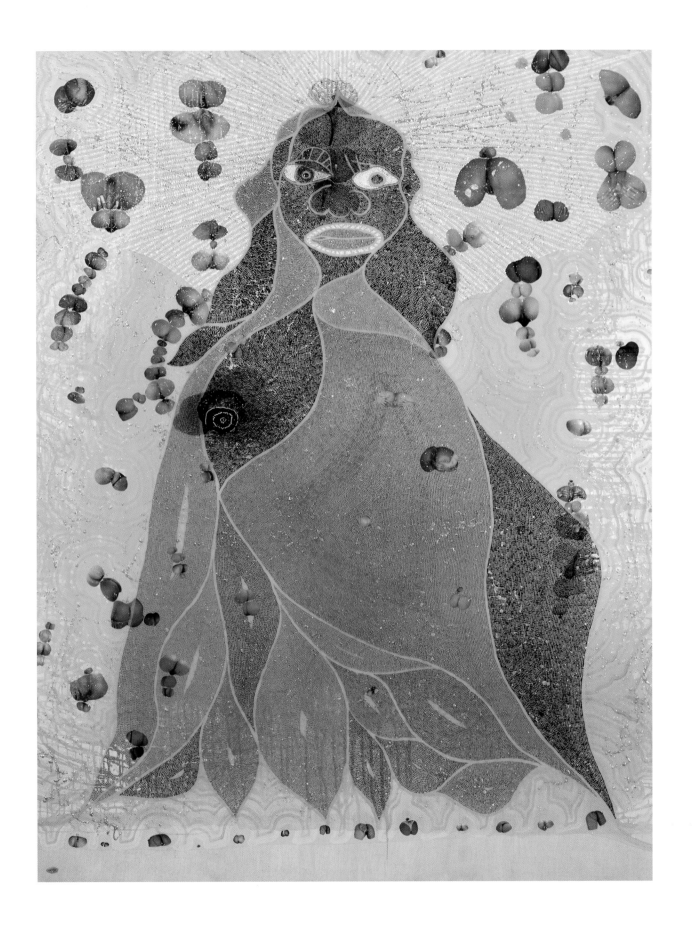

28 **CHRIS OFILI,**
 AFRODIZZIA, 1996
 paper collage, oil paint, glitter,
 polyester resin, map pins,
 elephant dung on linen,
 243.8 x 182.9cm (96 x 72in)

29 CHRIS OFILI,
AFROBLUFF, 1996
paper collage, oil paint, paper
collage, polyester resin, mapping
pins, elephant dung on linen,
96 x 72cm (37.8 x 28.3in)

30 CHRIS OFILI,
FOUR PLUS ONE MORE, 1998
mixed media on canvas,
182.9 x 121.9cm (72 x 48in)

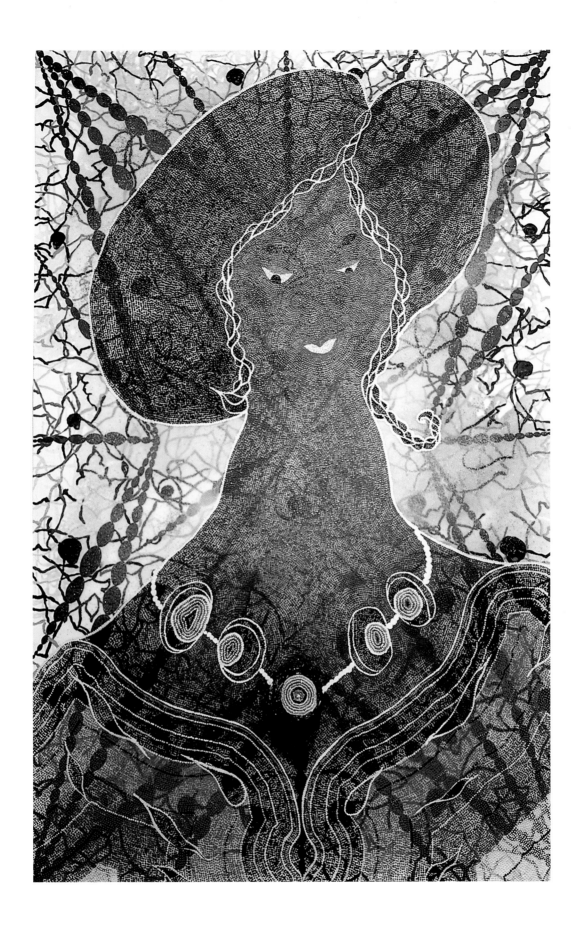

31 SARAH LUCAS, SELF-PORTRAIT
 WITH FRIED EGGS, 1996
 c-print, 167 x 119cm (65.8 x 47in)

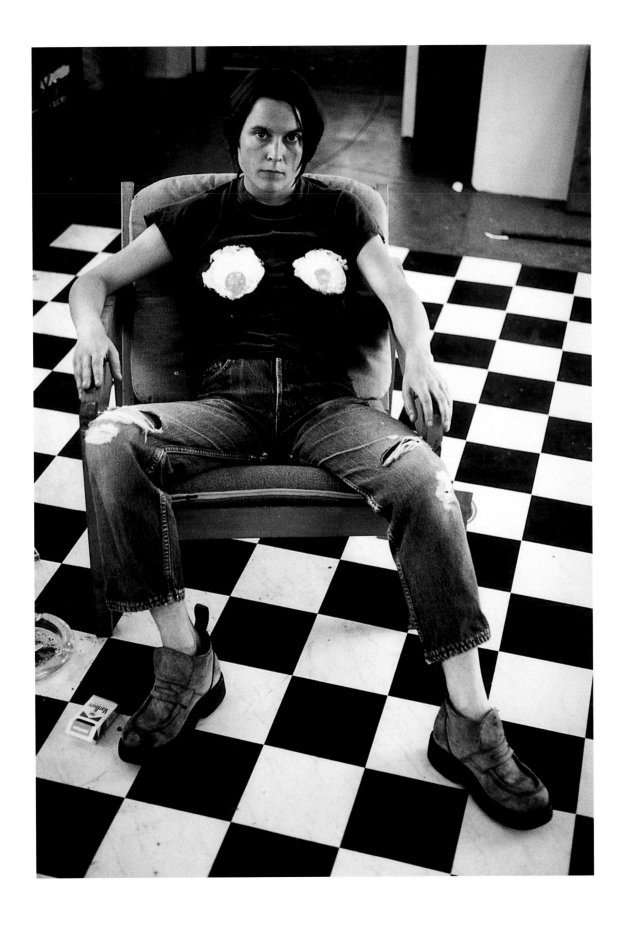

32 SARAH LUCAS,
SOD YOU GITS,
1990
photocopy
on paper,
216 x 315cm
(85 x 124in)

GITS WILD DY

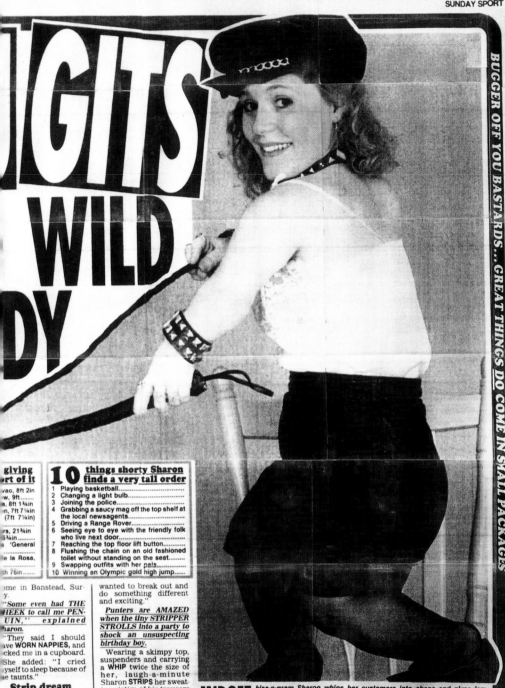

10 things shorty Sharon finds a very tall order

1 Playing basketball.....................
2 Changing a light bulb..................
3 Joining the police.....................
4 Grabbing a saucy mag off the top shelf at the local newsagents...................
5 Driving a Range Rover..................
6 Seeing eye to eye with the friendly folk who live next door...................
7 Reaching the top floor lift button.......
8 Flushing the chain on an old fashioned toilet without standing on the seat.......
9 Swapping outfits with her pals..........
10 Winning an Olympic gold high jump......

MIDGET kiss-o-gram Sharon whips her customers into shape and gives 'em plenty to smile about with her topless routine. Hubby's the minder

ome in Banstead, Surrey.

"Some even had THE CHEEK to call me PENGUIN," explained Sharon.

"They said I should have WORN NAPPIES, and locked me in a cupboard.

She added: "I cried myself to sleep because of he taunts."

Strip dream comes true

BUT Sharon says the ROTTEN SHITHEADS an stick the ABUSE up eir miserable ARSE-OLES.

The TITCHY TEASE is now making a MINT in her amazing career, with her ppointments diary RAMMED.

When she first announced she was going o take off her clothes for living, Paul had a FIT nd tried to BAN her 2-24-36 bouncy figure.

It was only when she greed to let Paul MIND er that her saucy strip ream finally came true.

"I've always wanted to o this. I've had other obs but they've always een behind a desk.

"They were so boring, I

wanted to break out and do something different and exciting."

Punters are AMAZED when the tiny STRIPPER STROLLS into a party to shock an unsuspecting birthday boy.

Wearing a skimpy top, suspenders and carrying a WHIP twice the size of her, laugh-a-minute Sharon STRIPS her sweating victim of his trousers and boxers and starts THRASHING with her leather weapon.

"I don't hit too hard, just enough to make 'em sit up and take notice," she said.

"When I've pulled their pants down, I take my top off to bare my boobs.

"By now they're usually SPEECHLESS at what this little thing is doing to them and too shocked to put up a fight. I've never had a failure yet."

And short-house husband Paul, 20, stands by his wife.

"I was very surprised when she first told me that's what she wanted to do," he said from the LOVE-NEST they now share in Southwark.

"It's not for me to stop

Sharon doing something she really wants to. Now I just GRIN and BEAR IT.

"I stand quietly a few yards from her and keep an eye on the proceedings.

"My height doesn't mean a thing to me. I can get a bit firm with whoever is causing the trouble. I'm not scared and I've got a few surprises up my sleeve."

With husband Paul keeping his eye out, Sharon runs in and out of their LEGS to stop them getting too near when they get frisky.

"I've got to make the most of my height. Being the smallest stripper in the world is one way of doing it."

SHE'S ONE-IN-A-MILLION...

AGAINST CRUEL SHITHEADS WHO CALL HER A PENGUIN...

**33 SARAH LUCAS, TWO FRIED
EGGS AND A KEBAB, 1992**
photograph, fried eggs, kebab,
table, 76.2 x 152.4 x 89cm
(30 x 60 x 35in)

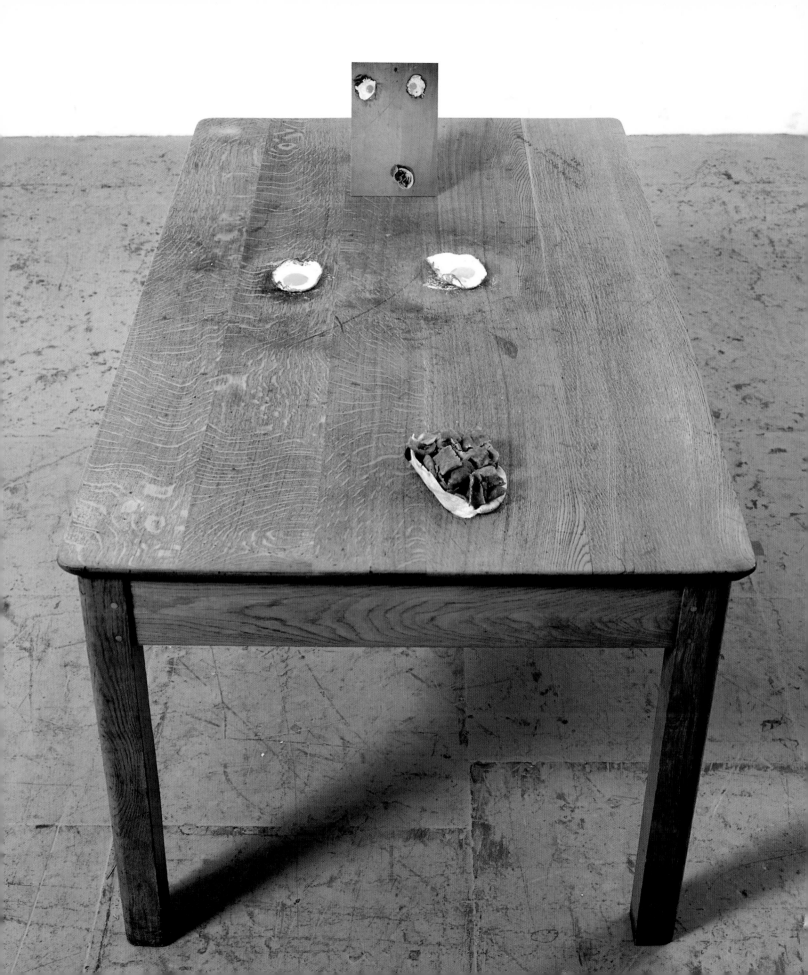

34 SARAH LUCAS,
AU NATUREL, 1994
mattress, water bucket,
melons, oranges, cucumber,
83.2 x 167.6 x 144.8cm
(33 x 66 x 57in)

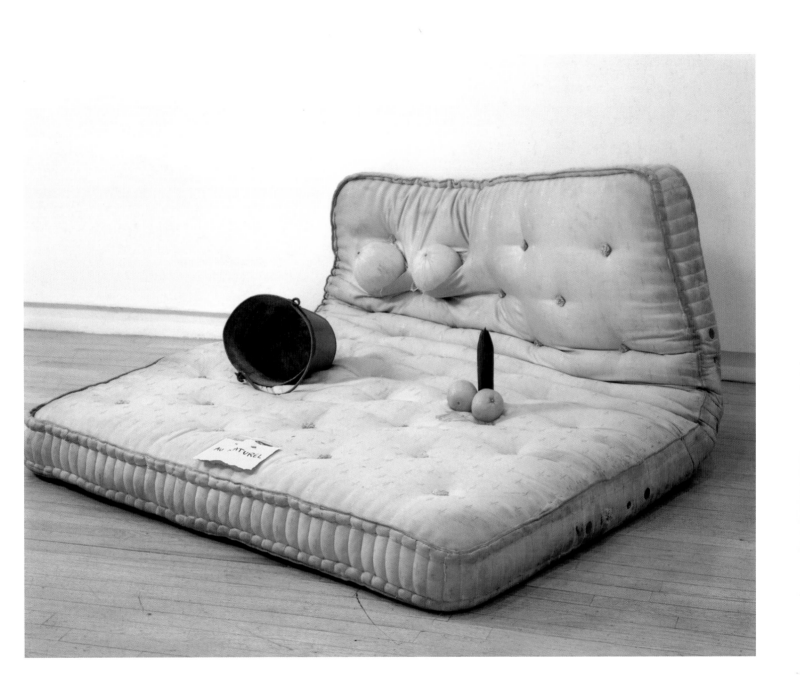

35 **SARAH LUCAS, DREAMS
 GO UP IN SMOKE, 2000**
 cast bronze and cigarettes,
 142 x 82 x 62cm (60 x 32.3 x 24.5in)

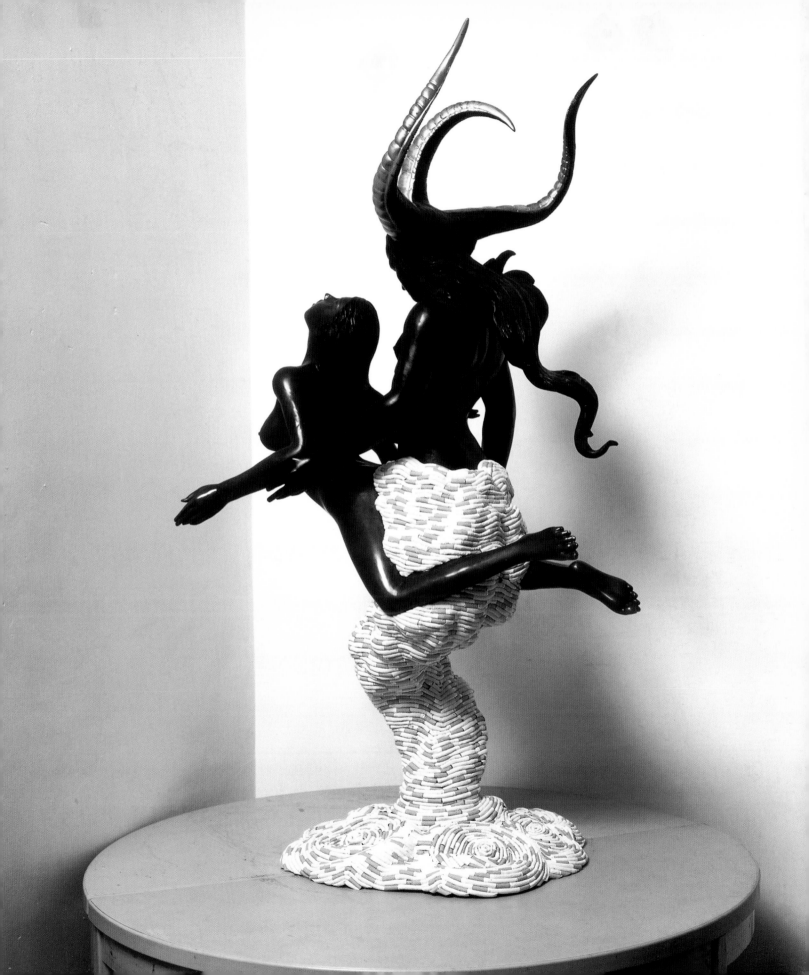

36 **SARAH LUCAS, BUNNY, 1997**
tights, plywood chair, clamp,
kapok, stuffing, wire,
101.5 x 90 x 63.5cm (40 x 35.5 x 25in)

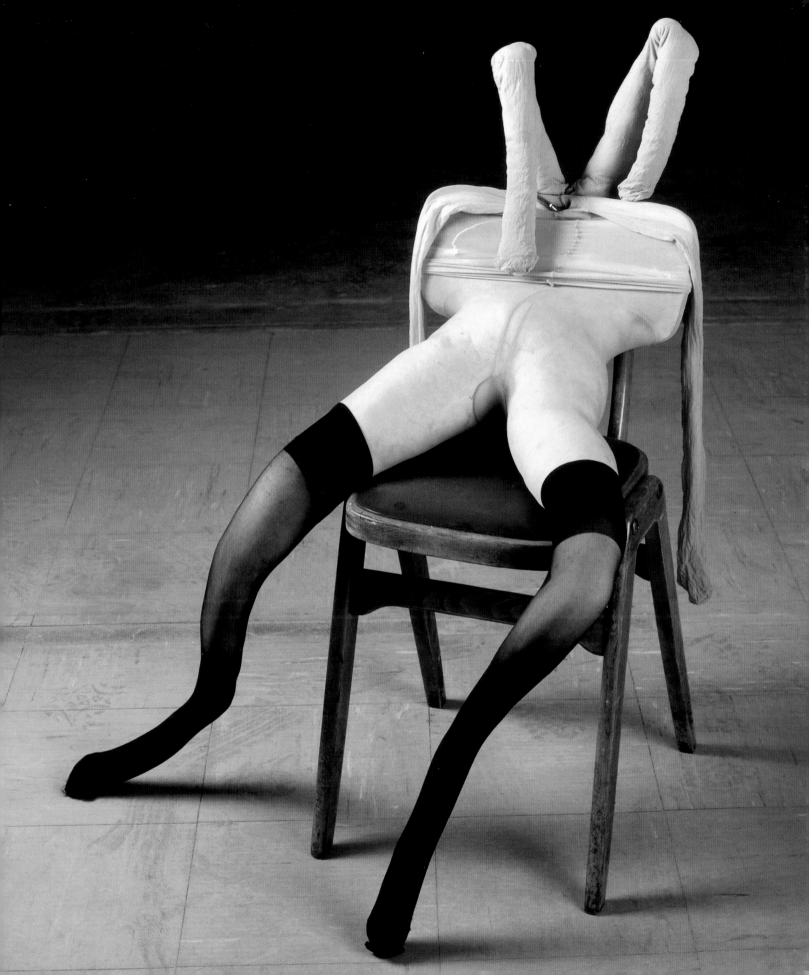

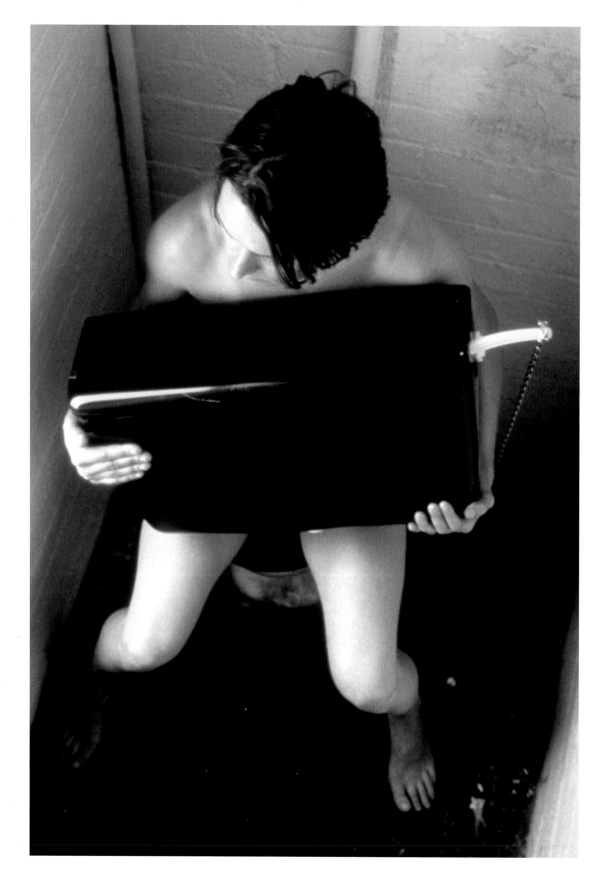

37 SARAH LUCAS, HUMAN TOILET, 1997
c-print, 244 x 188.5cm (96 x 74in)

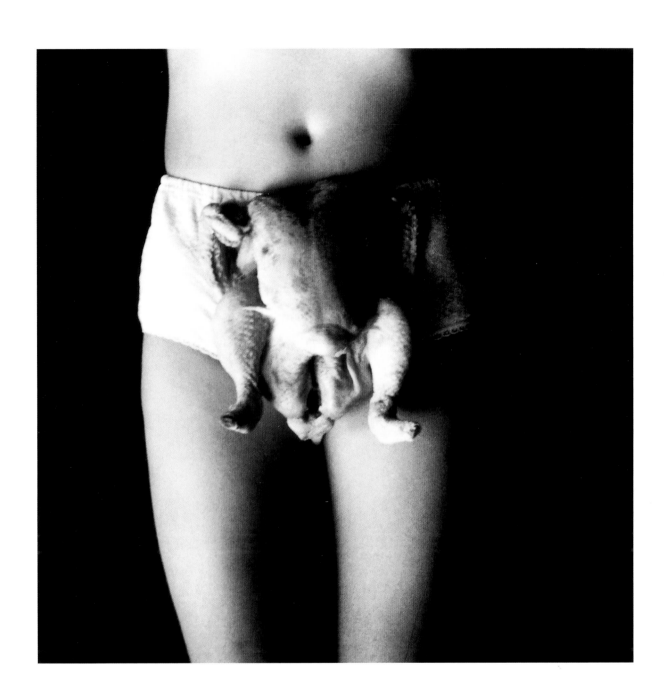

38 SARAH LUCAS, CHICKEN KNICKERS, 2000
c-type photograph, 273.2 x 196.3cm (107.5 x 77.3in)

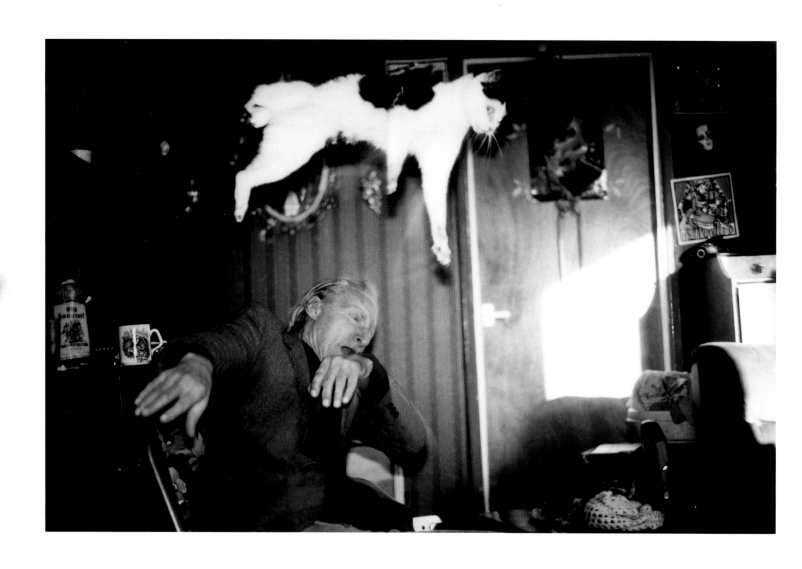

39 RICHARD BILLINGHAM,
UNTITLED, 1995
SFA4 colour photograph on aluminium,
105 x 158cm (41.3 x 62.2in)

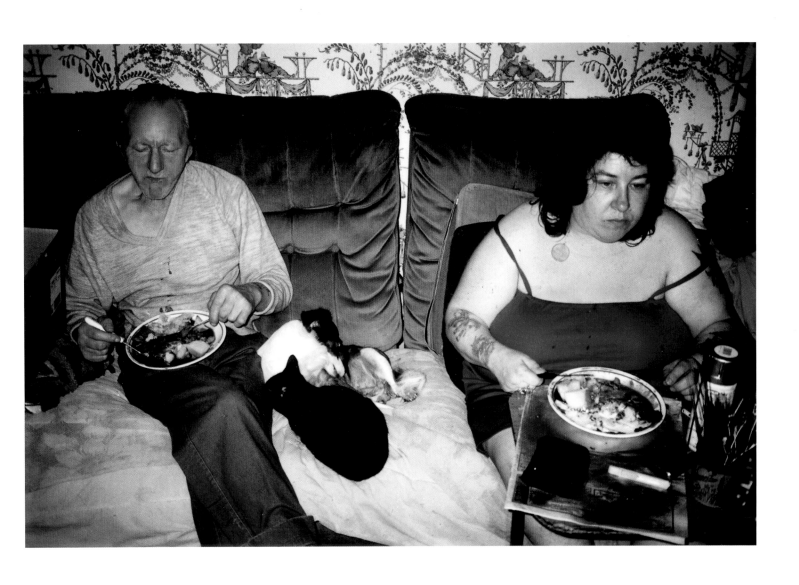

40 **RICHARD BILLINGHAM,**
 UNTITLED, 1995
 SFA4 colour photograph on aluminium,
 80 x 120cm (31.5 x 47.2in)

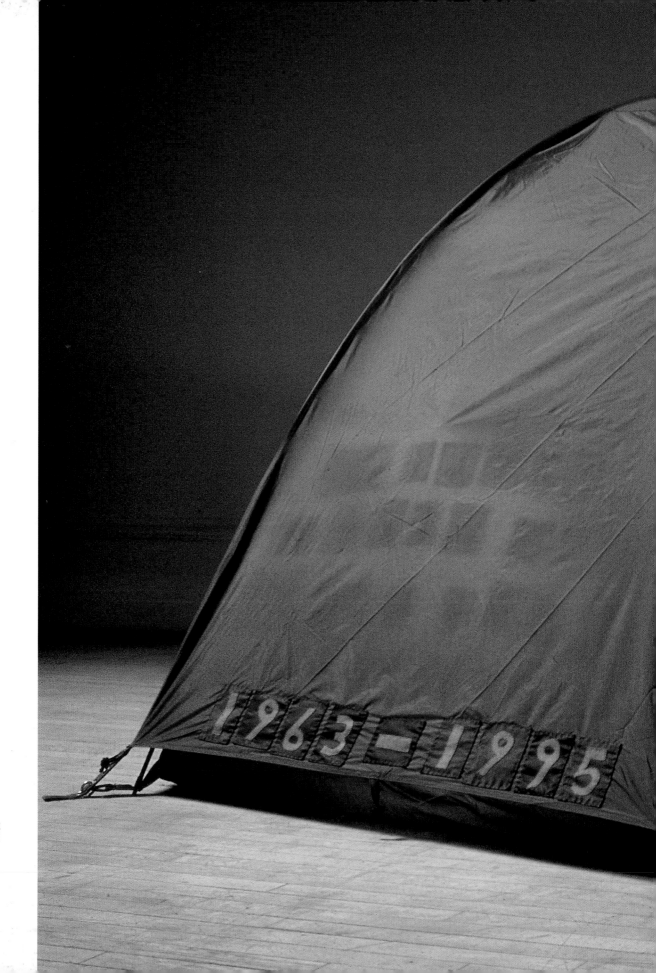

41 TRACEY EMIN,
EVERYONE I HAVE
EVER SLEPT WITH
1963–1995, 1995
appliquéd tent,
mattress, light,
122 x 245 x 215cm
(48 x 69.4 x 84.6in)

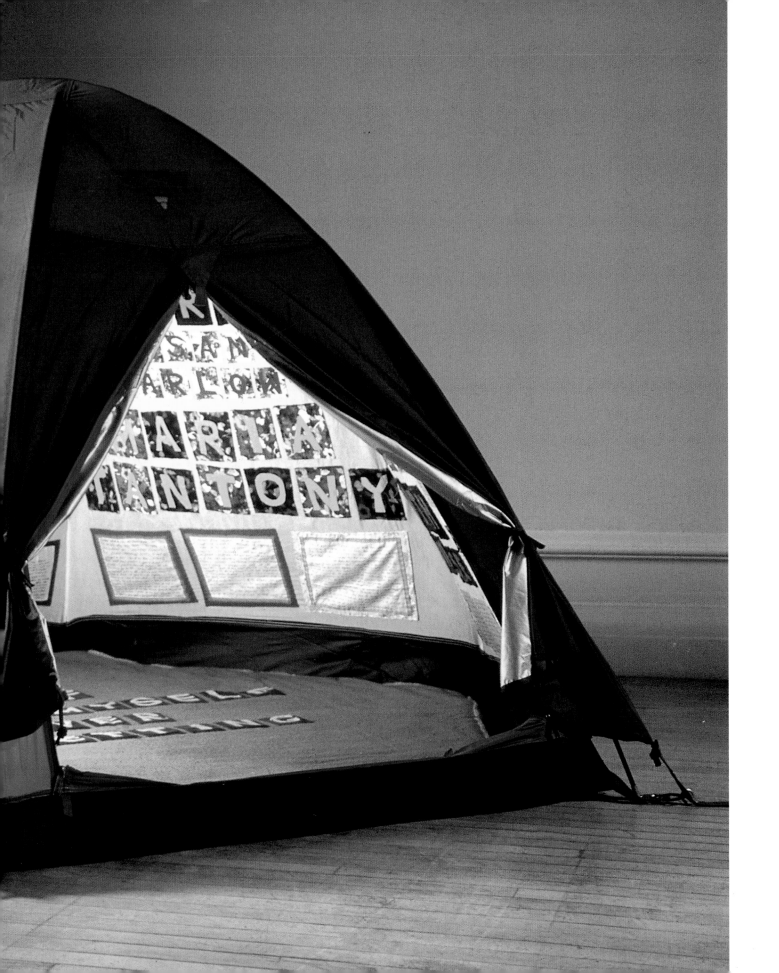

41 TRACEY EMIN, EVERYONE I HAVE EVER
SLEPT WITH 1963–1995, 1995 (detail)
appliquéd tent, mattress, light,
122 x 245 x 215cm (48 x 69.4 x 84.6in)

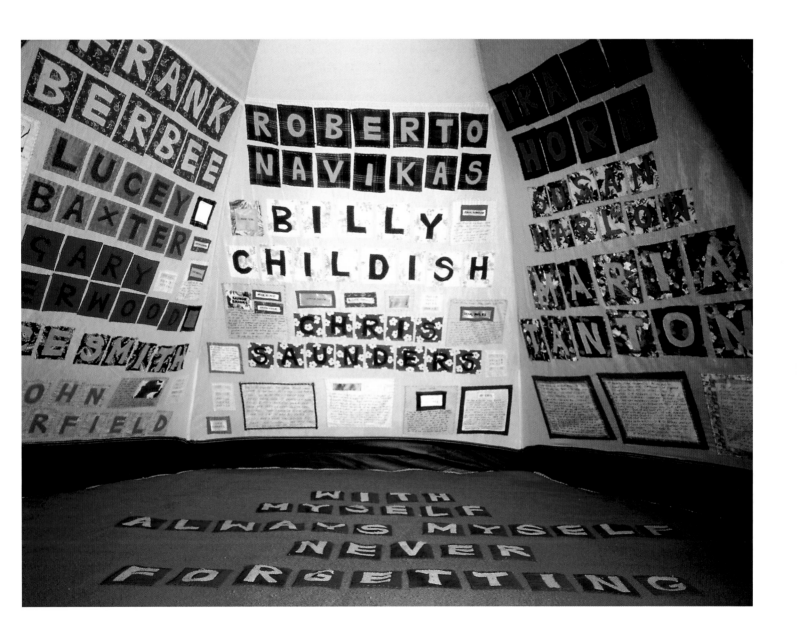

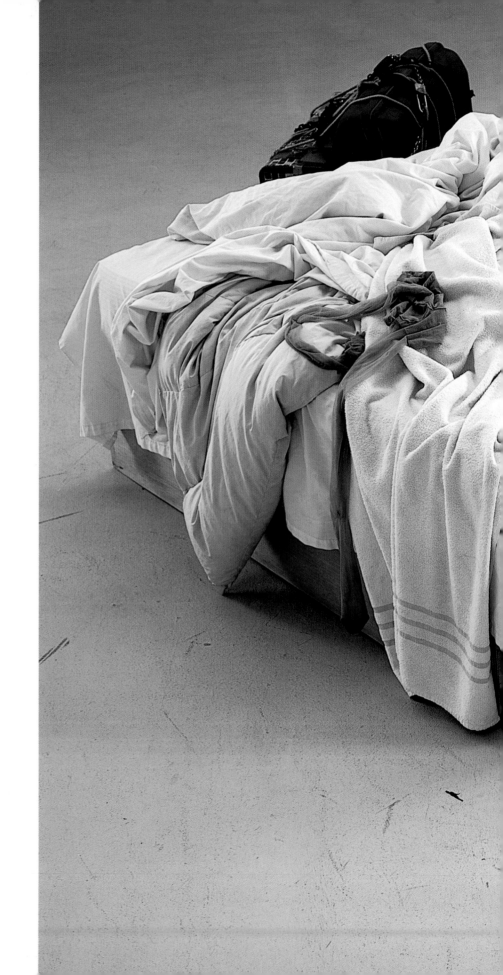

42 TRACEY EMIN, MY BED, 1998
mattress, linens, pillows, objects,
79 x 211 x 234cm (31 x 83 x 92in)

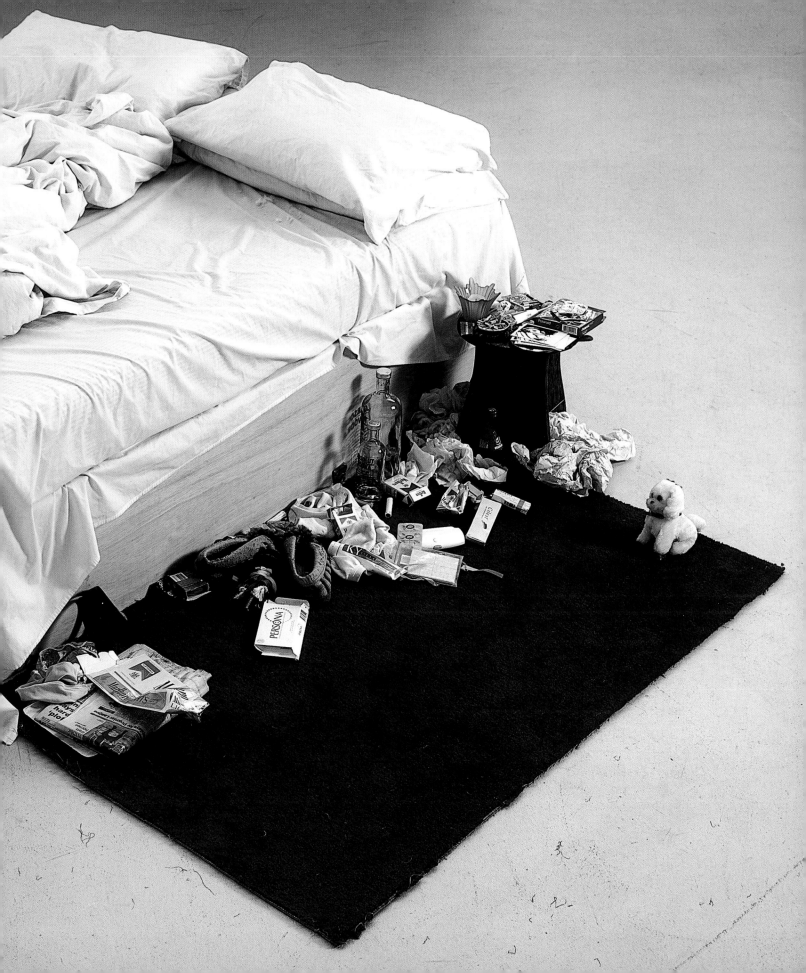

43　**TRACEY EMIN, EXORCISM OF THE
LAST PAINTING I EVER MADE, 1996**
installation including 14 paintings, 78 drawings,
5 body prints, various painted and personal items,
furniture, CDs, newspapers, magazines, kitchen
and food supplies, dimensions variable

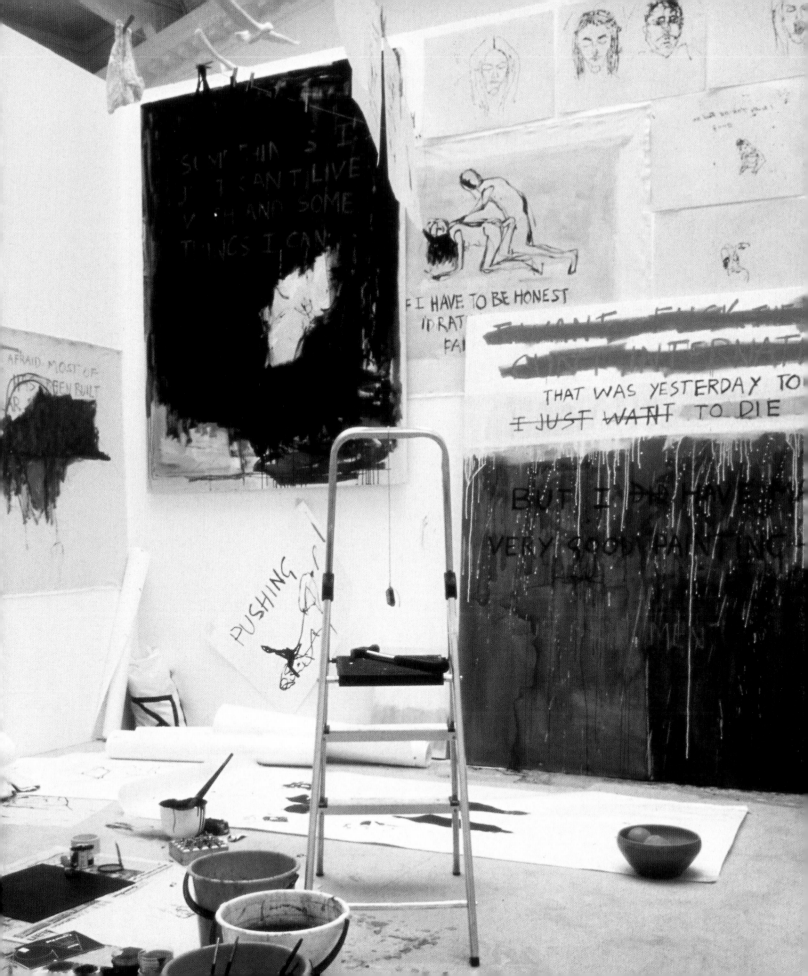

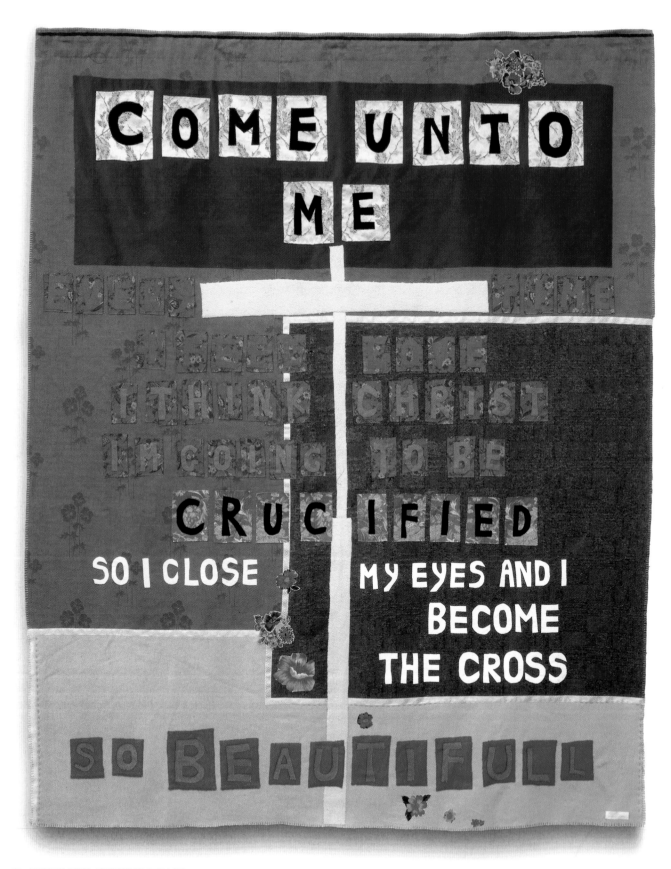

44 TRACEY EMIN, AUTOMATIC ORGASM, 2001
appliquéd blanket, 263 x 214cm (103.5 x 84.25in)

45 TRACEY EMIN, SOMETHING I'VE ALWAYS BEEN AFRAID OF, 2002
appliquéd blanket, 263 x 174cm (103.5 x 68.5in)

46 TRACEY EMIN, I THINK IT MUST HAVE BEEN FEAR, 2000
appliquéd blanket, 232 x 200cm (91.3 x 78.75in)

HOW COULD I EVER
LEAVE YOU

I LOVE YOU

I SEARCH THE

WORLD

I KISS YOU

I'M WET WITH

FEAR

I AM

INTERNATIONAL WOMAN

47 TRACEY EMIN, TERMINAL 1, 2000
appliquéd blanket, 230 x 210cm (90.5 x 82.7in)

48 TRACEY EMIN,
I'VE GOT IT ALL, 2000
ink-jet print, 122 x 91.5cm
(48 x 36in)

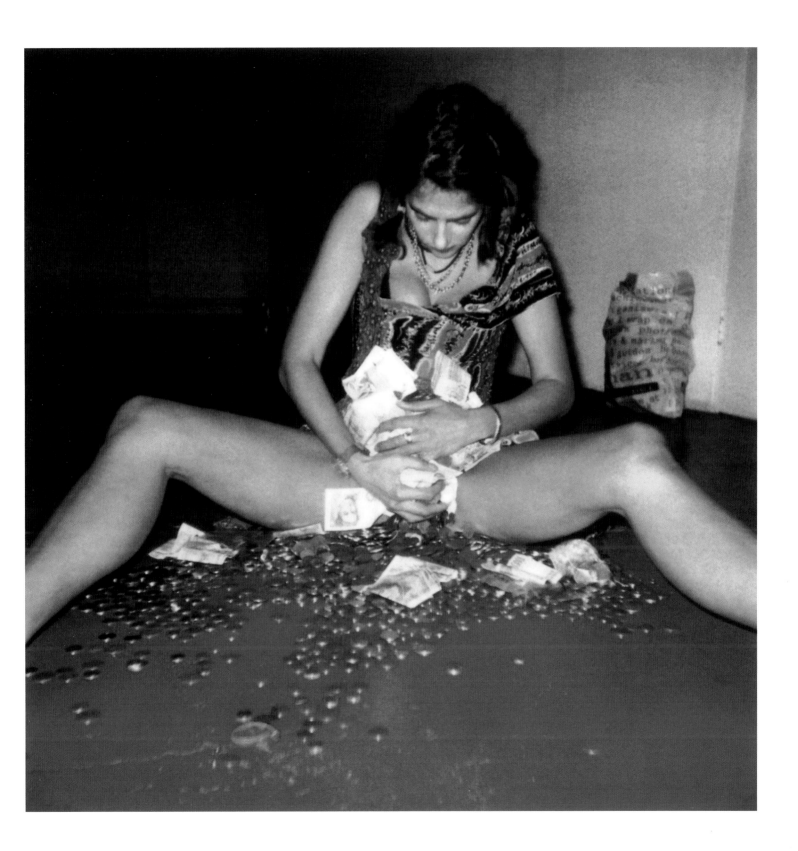

49 TRACEY EMIN, THE LAST
THING I SAID TO YOU IS
DON'T LEAVE ME HERE, 1999
mixed media, 292 x 447 x 244cm
(115 x 176 x 96in)

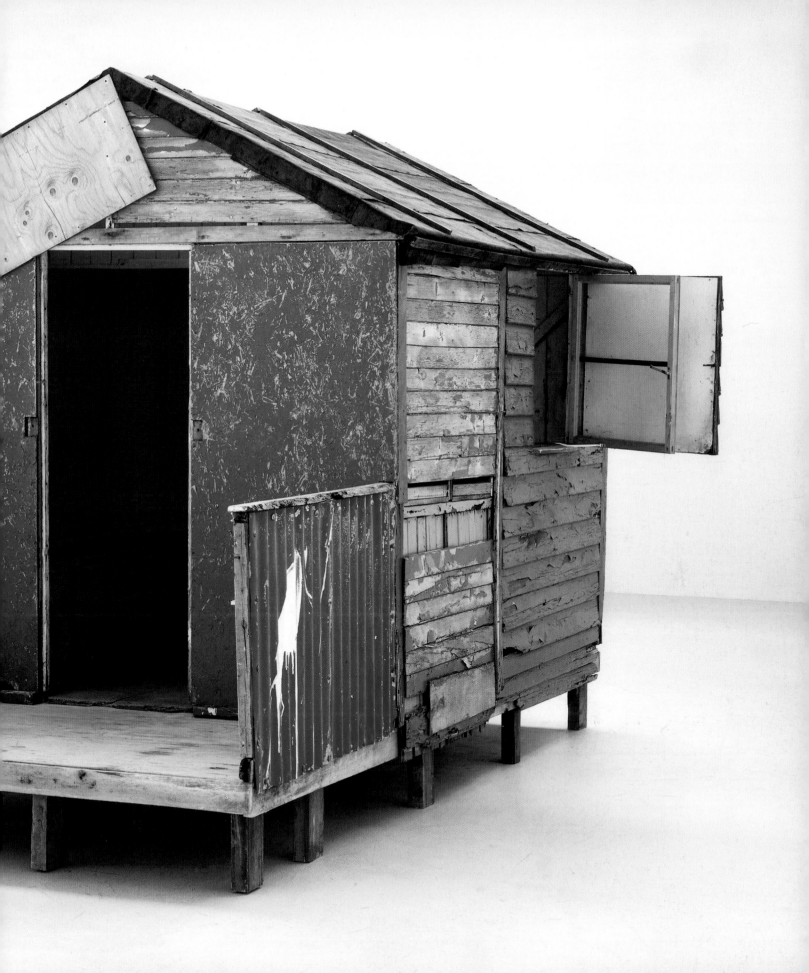

50 PETER DOIG,
 SNOWBALLED BOY, 1995
 oil on wood, 60.5 x 40cm
 (24 x 16in)

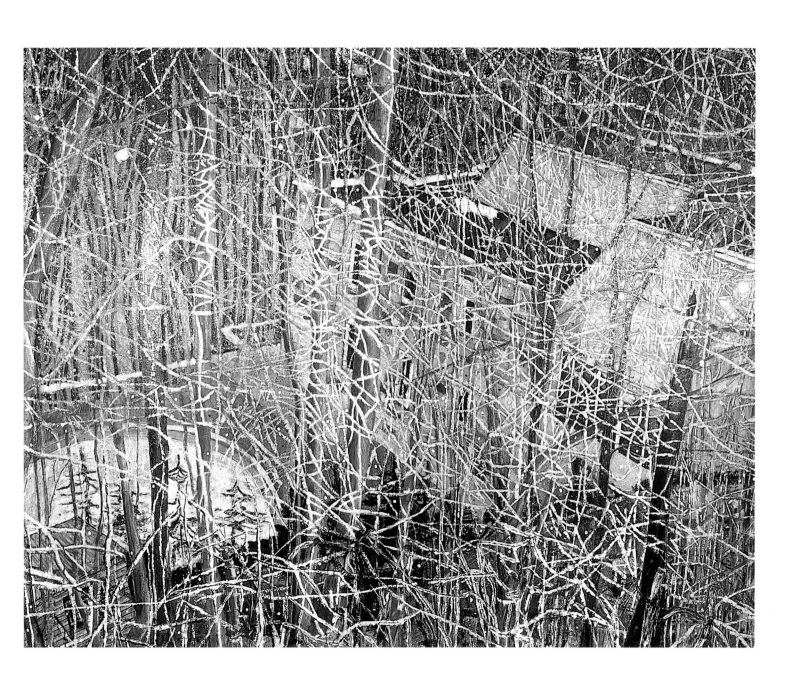

51 PETER DOIG,
 THE ARCHITECT'S HOME
 IN THE RAVINE, 1991
 oil on canvas, 200 x 275cm
 (79 x 108in)

52 PETER DOIG,
WHITE CANOE, 1990–1991
oil on canvas, 200.5 x 242.8 x 5.7cm
(79 x 96 x 2in)

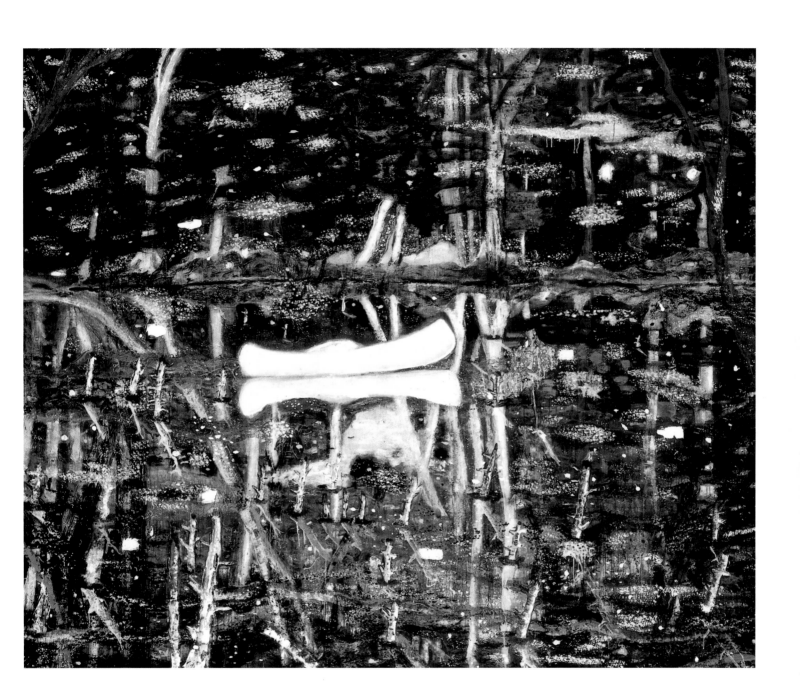

53 GARY HUME,
VICIOUS, 1994
gloss paint on panel,
218 x 181cm (86 x 71in)

54 GARY HUME,
BEGGING FOR IT, 1994
gloss paint on panel,
200 x 150cm (78.7 x 59in)

55 GARY HUME,
FOUR DOORS, 1989–90
gloss paint on four panels,
238.8 x 594.4cm (94 x 234in)

56 **SIMON PATTERSON,**
 GREAT BEAR, 1995
 lithography print and anodised
 aluminium, frame with glass,
 109 x 134.8 x 5cm
 (42.9 x 53 x 1.95in)

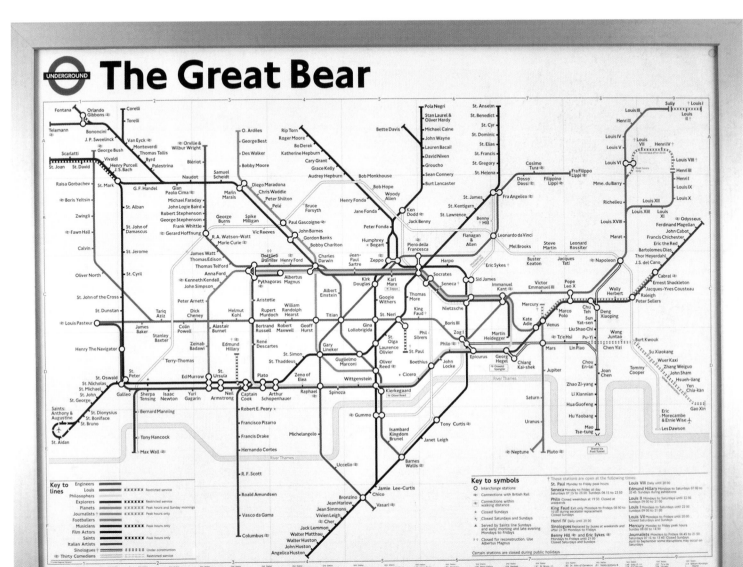

The Great Bear

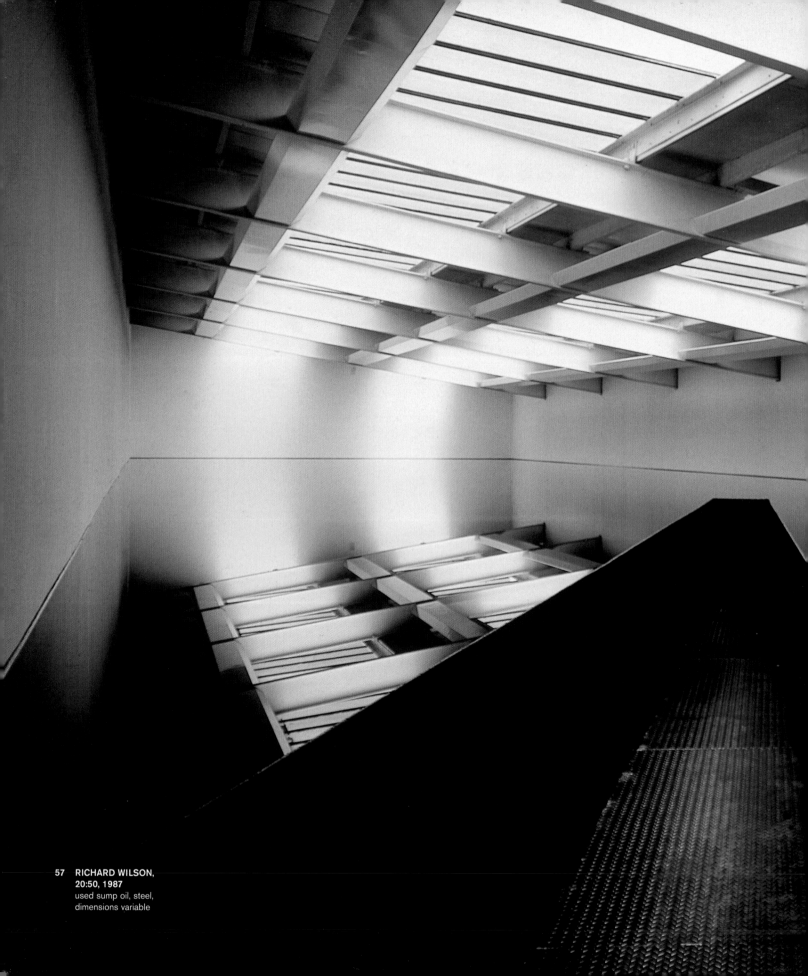

57 RICHARD WILSON,
20:50, 1987
used sump oil, steel,
dimensions variable

58 **RACHEL WHITEREAD,**
GHOST, 1990
plaster on steel frame,
269 x 355.5 x 317.5cm
(106 x 140 x 125in)

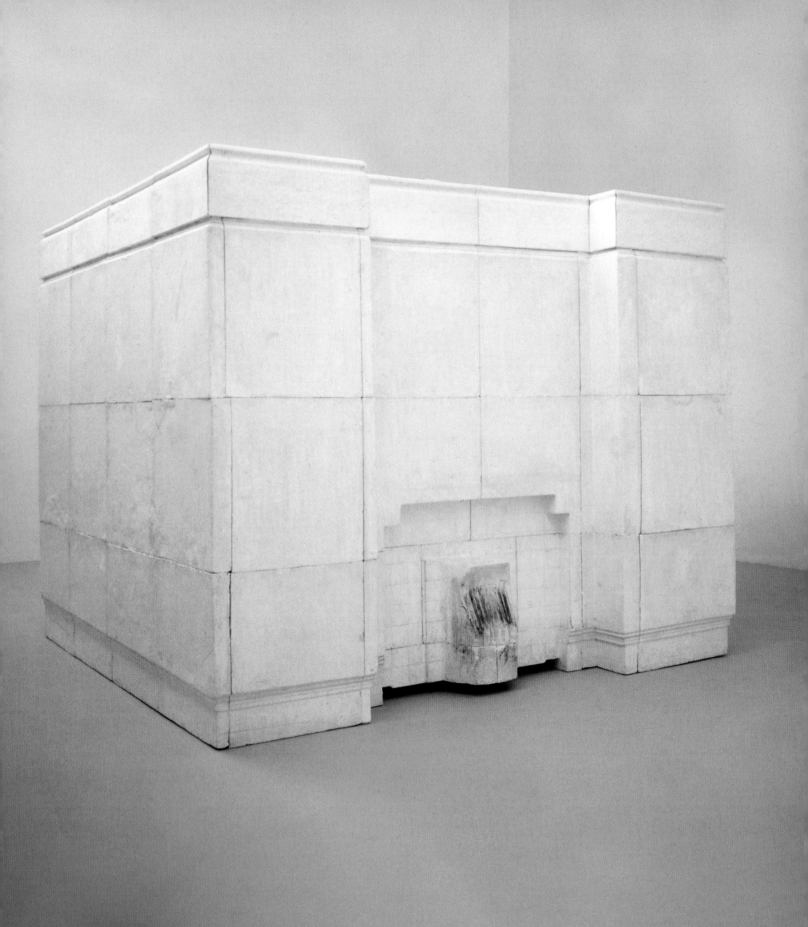

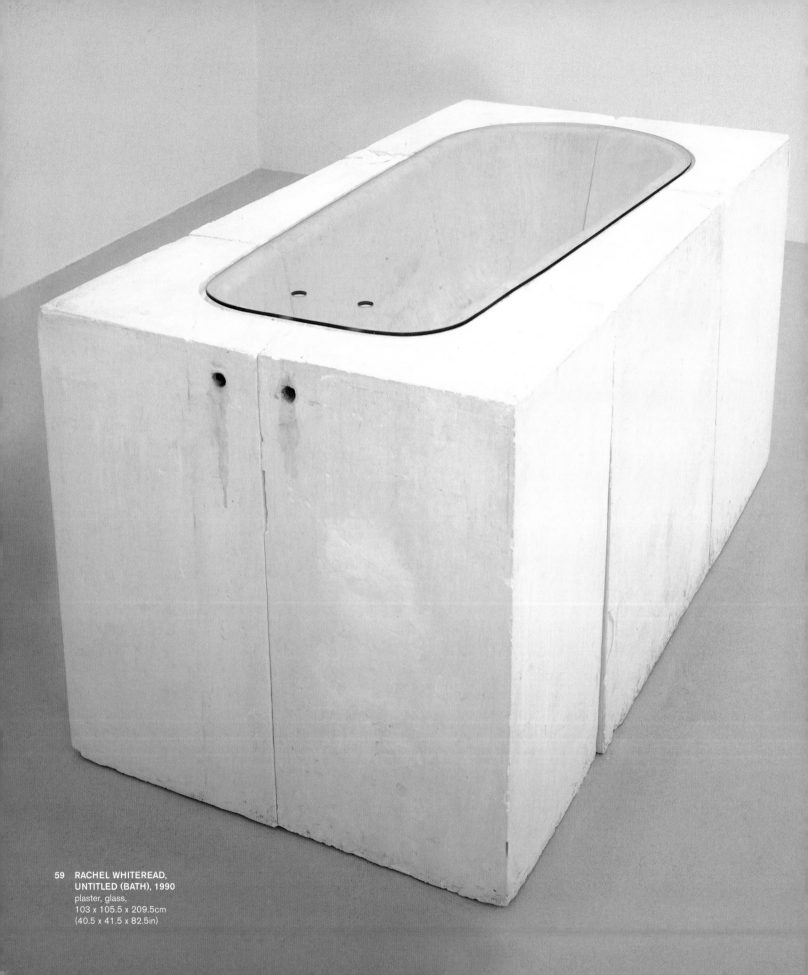

59 RACHEL WHITEREAD,
 UNTITLED (BATH), 1990
 plaster, glass,
 103 x 105.5 x 209.5cm
 (40.5 x 41.5 x 82.5in)

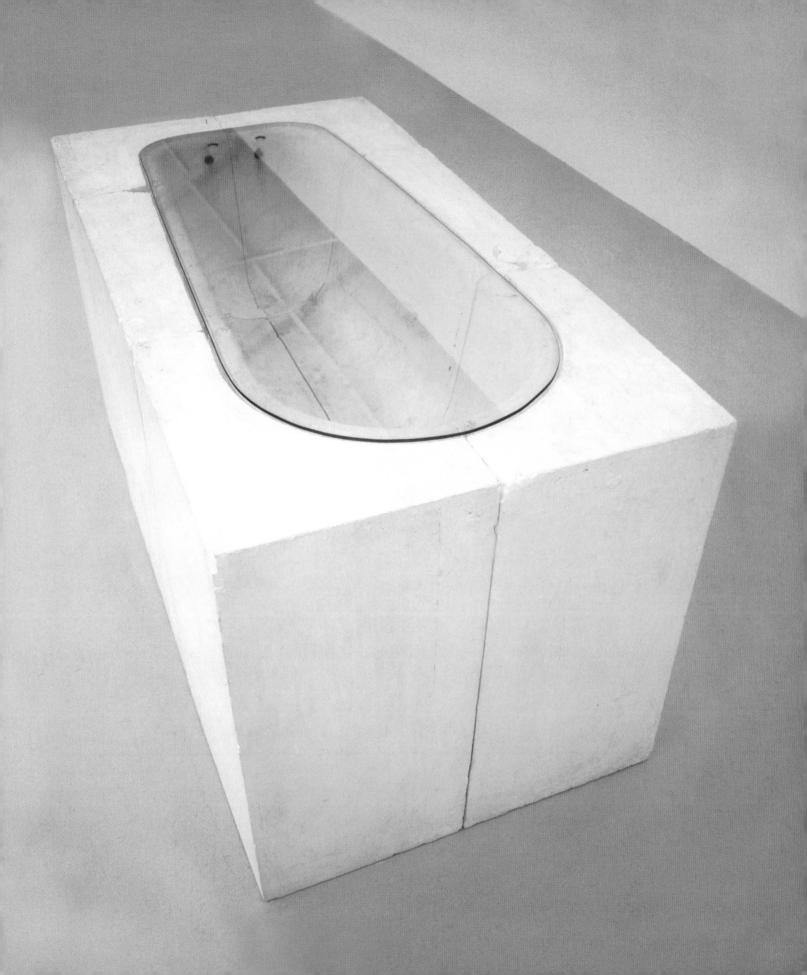

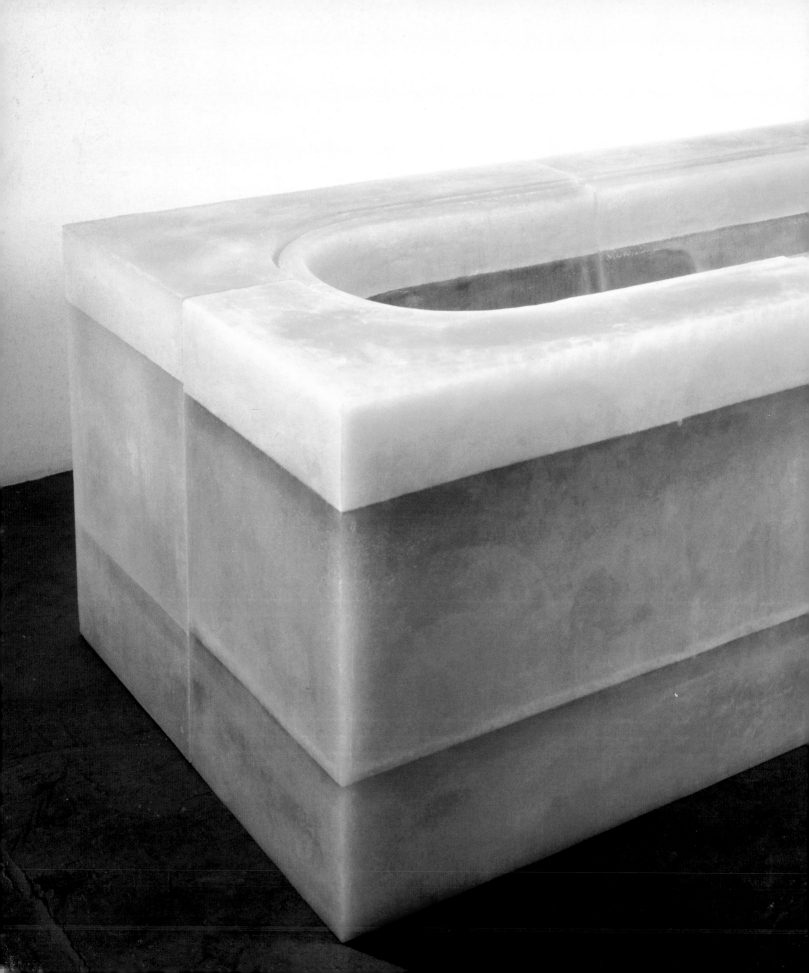

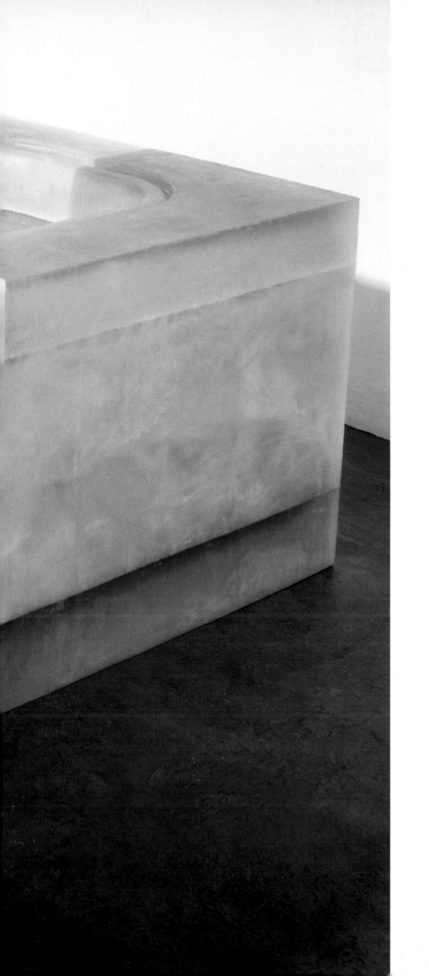

60 RACHEL WHITEREAD,
 UNTITLED (ORANGE BATH), 1996
 rubber, polystyrene, 80 x 207 x 110cm
 (31.5 x 81.5 x 43.31in)

61 GAVIN TURK,
DEATH OF CHE, 2000
waxwork and mixed media,
130 x 255 x 120cm
(51.2 x 100.5 x 47.2in)

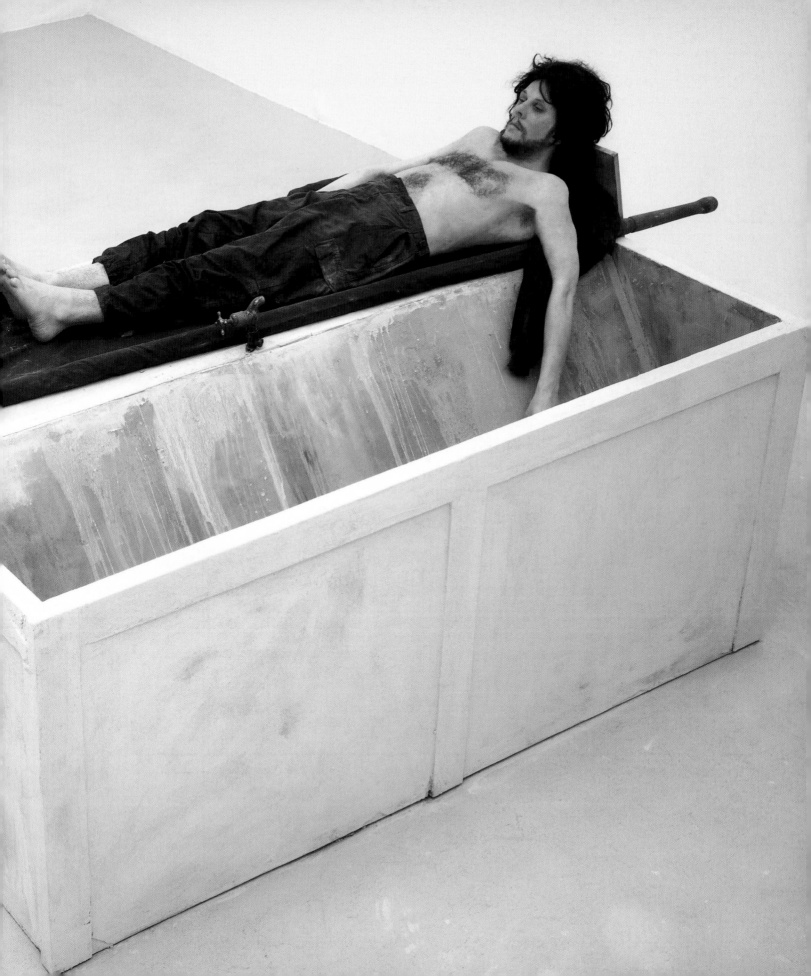

GAVIN TURK,
NOMAD, 2003
painted bronze,
42 x 105 x 169cm
(16.5 x 41.5 x 66.5in)

63 GAVIN TURK,
POP, 1993
glass, brass, MDF,
fibreglass, wax, clothing, gum,
279 x 115 x 115cm (110 x 45 x 45in)

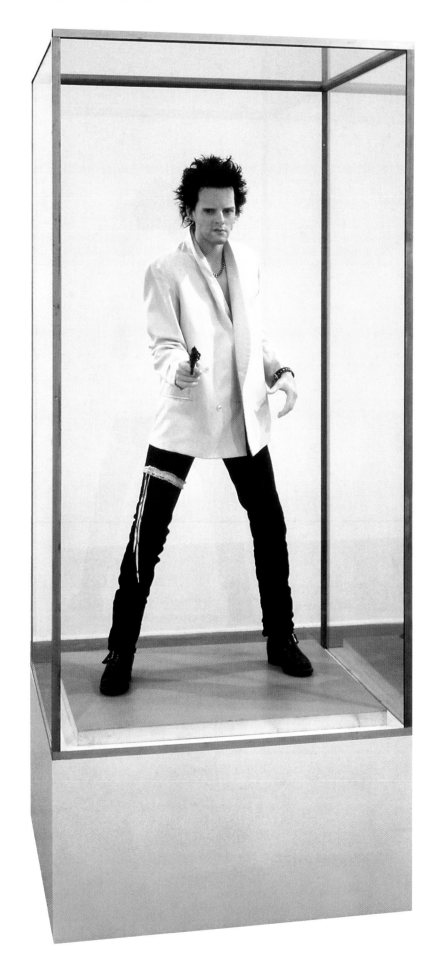

64 **MAT COLLISHAW,**
BULLET HOLE, 1988
cibachrome mounted
on 15 light boxes,
228.6 x 310cm (90 x 122in)

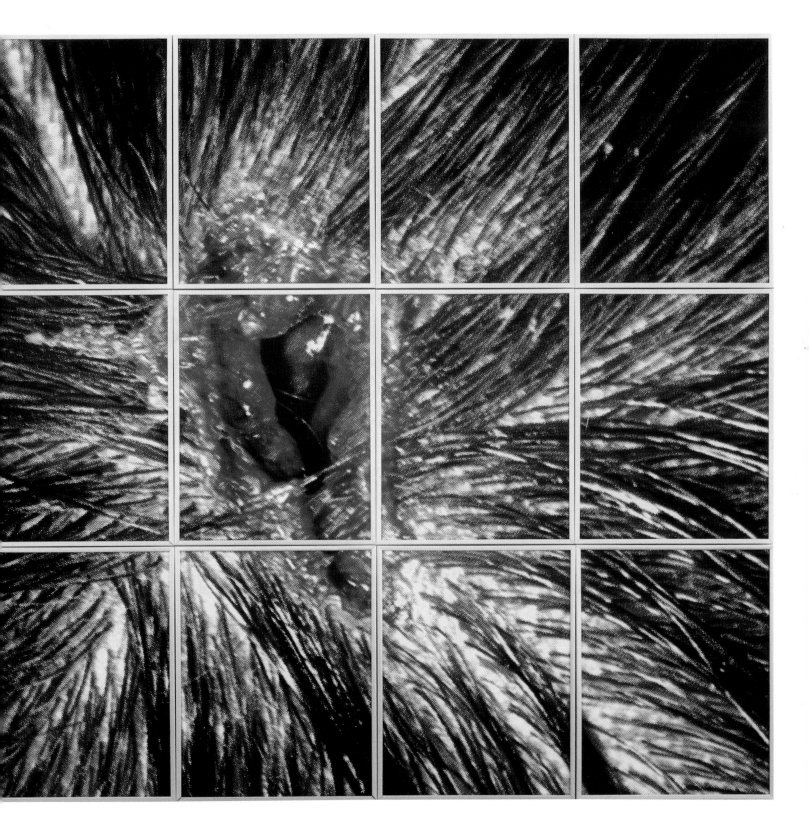

65 MARCUS HARVEY,
 JULIE FROM HULL, 1994
 oil and acrylic on canvas,
 244 x 244cm (96 x 96in)

66 MARCUS HARVEY,
MYRA, 1995
acrylic on canvas,
396 x 320cm (156 x 126in)

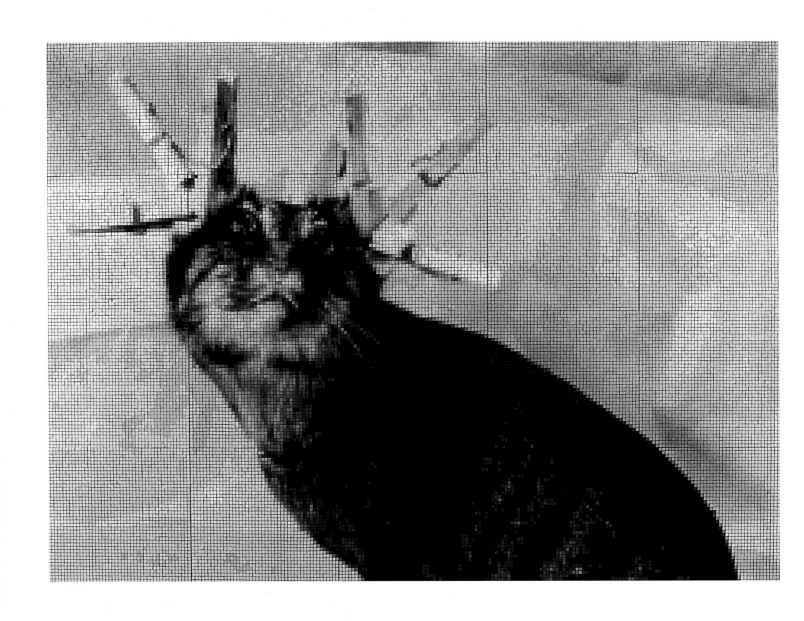

67 MAT COLLISHAW,
CORONNA, 2002
ceramic, cement, wood, paint,
350 x 490cm (138 x 193in)

**68 MAT COLLISHAW,
MADONNA, 2002**
ceramic, cement, wood, paint,
425 x 258cm (167 x 102in)

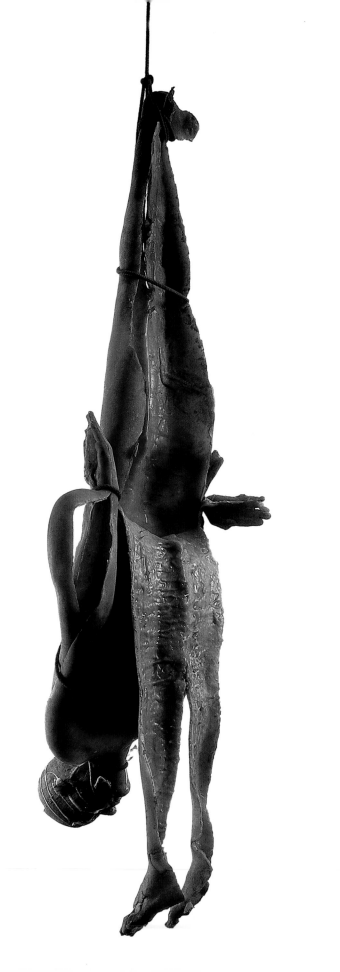

69 MARC QUINN, NO VISIBLE
MEANS OF ESCAPE, 1996
RTV 74–30 and rope,
180.3 x 59.7 x 30.5cm
(71 x 23.5 x 12in)

70 MARC QUINN,
 SELF, 1991
 blood, stainless steel, perspex,
 refrigeration equipment,
 208 x 63 x 63cm (82 x 25 x 25in)

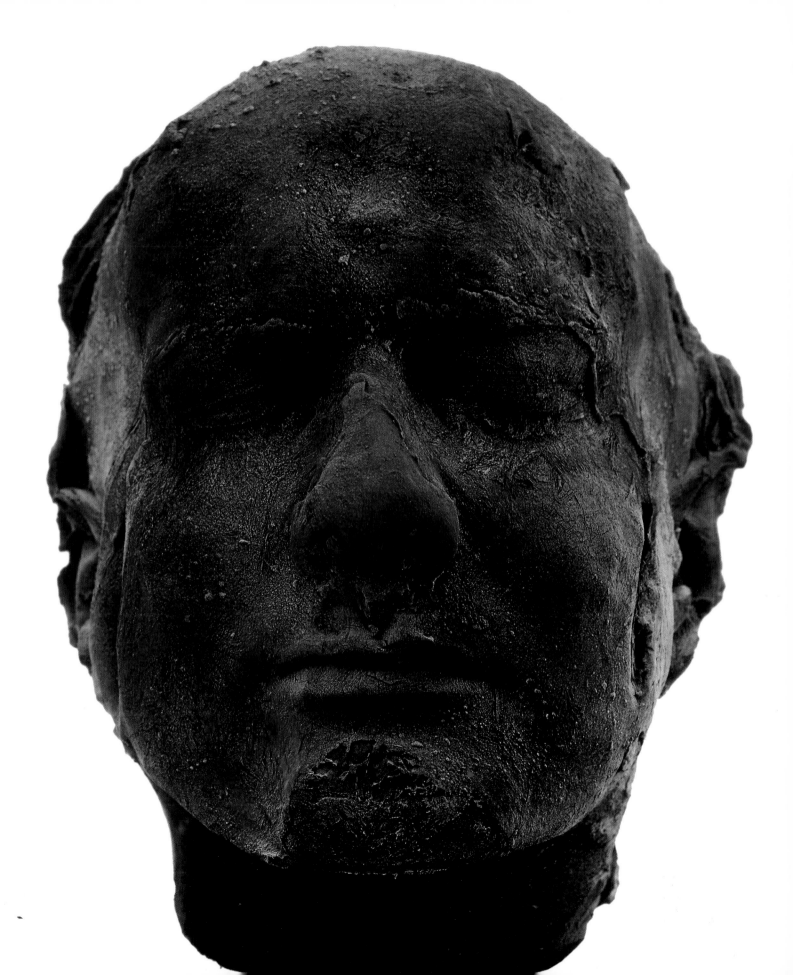

71 RACHEL WHITEREAD,
UNTITLED (ONE HUNDRED SPACES), 1995
resin, 100 units, size according to installation

WAVE 2

**72 TIM NOBLE AND SUE WEBSTER,
TOXIC SCHIZOPHRENIA, 1997**
516 UFO clamps, lamps and
holders, 6mm foamex, vinyl, aerosol,
260 x 200cm (102.4 x 78.7in)

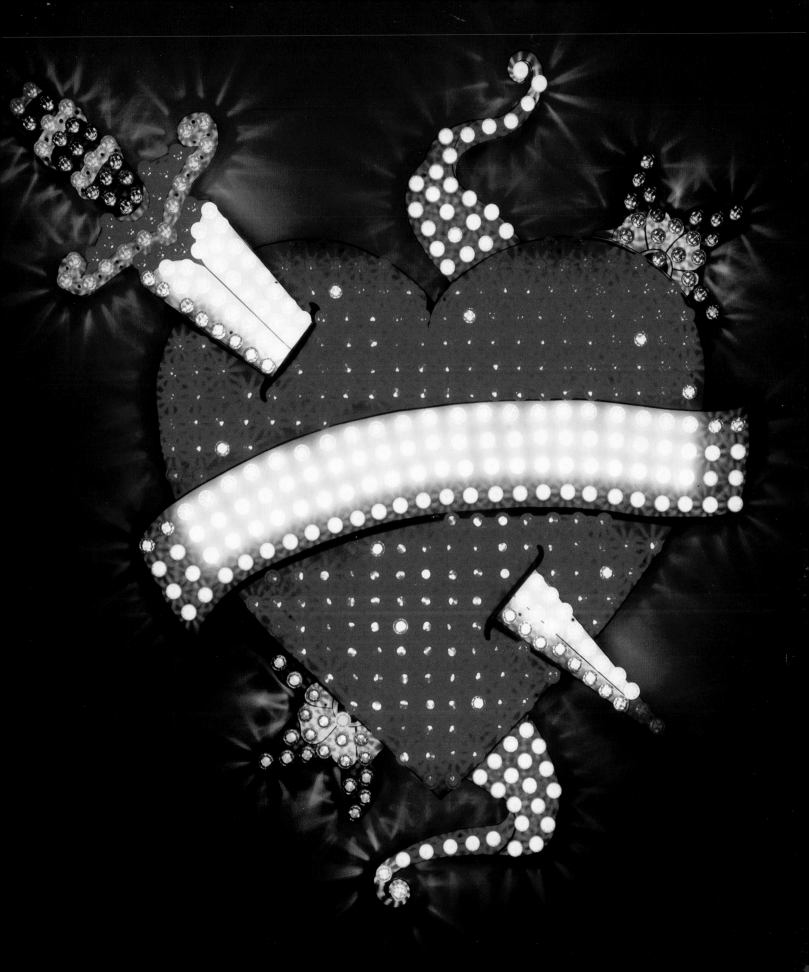

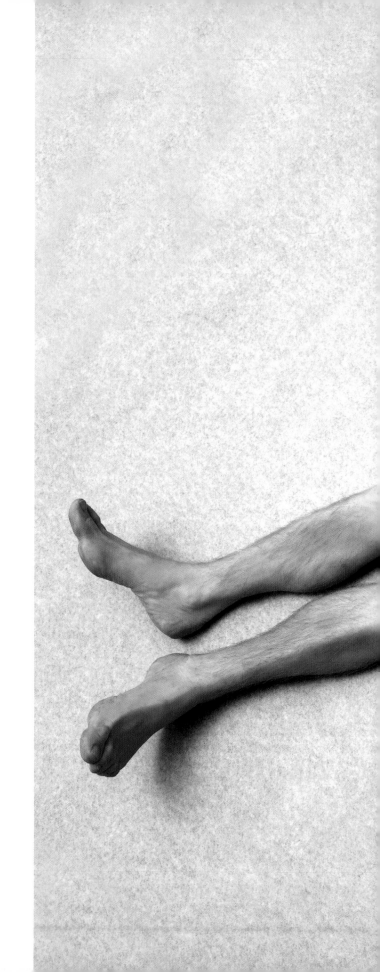

73 RON MUECK,
DEAD DAD, 1996–97
silicone and acrylic,
20 x 102 x 38cm (79 x 40 x 15in)

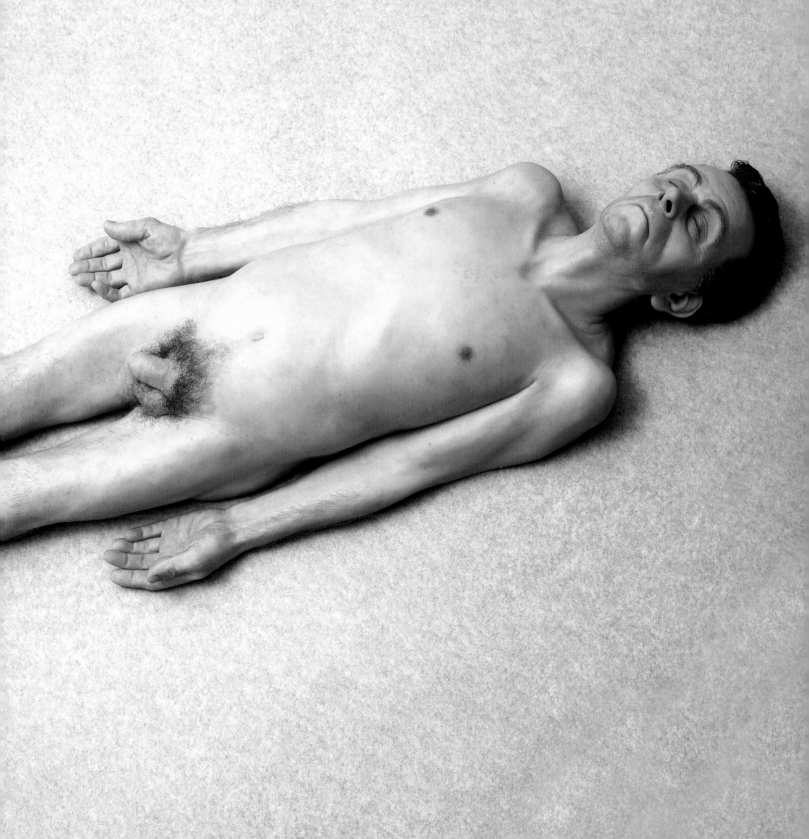

74 RON MUECK,
MASK, 1997
polyester resin and mixed media,
158 x 153 x 124cm
(62.2 x 60.23 x 48.81in)

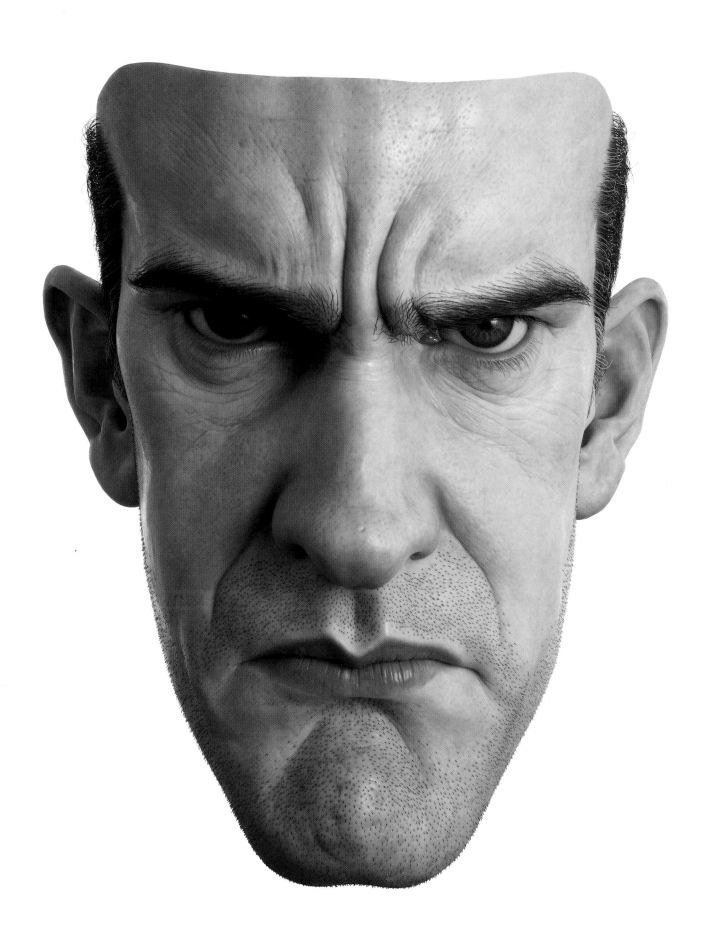

75 RON MUECK, PINOCCHIO, 1996
polyester resin, fibreglass, human hair,
84 x 20 x 18cm (33 x 8 x 7in)

76 RON MUECK, BIG BABY, 1996
polyester resin, fibreglass, human hair,
85 x 71 x 70cm (33 x 28 x 28in)

77 RON MUECK,
ANGEL, 1997
silicone rubber
and mixed media,
110 x 87 x 81cm
(43.3 x 34.25 x 31.88in)

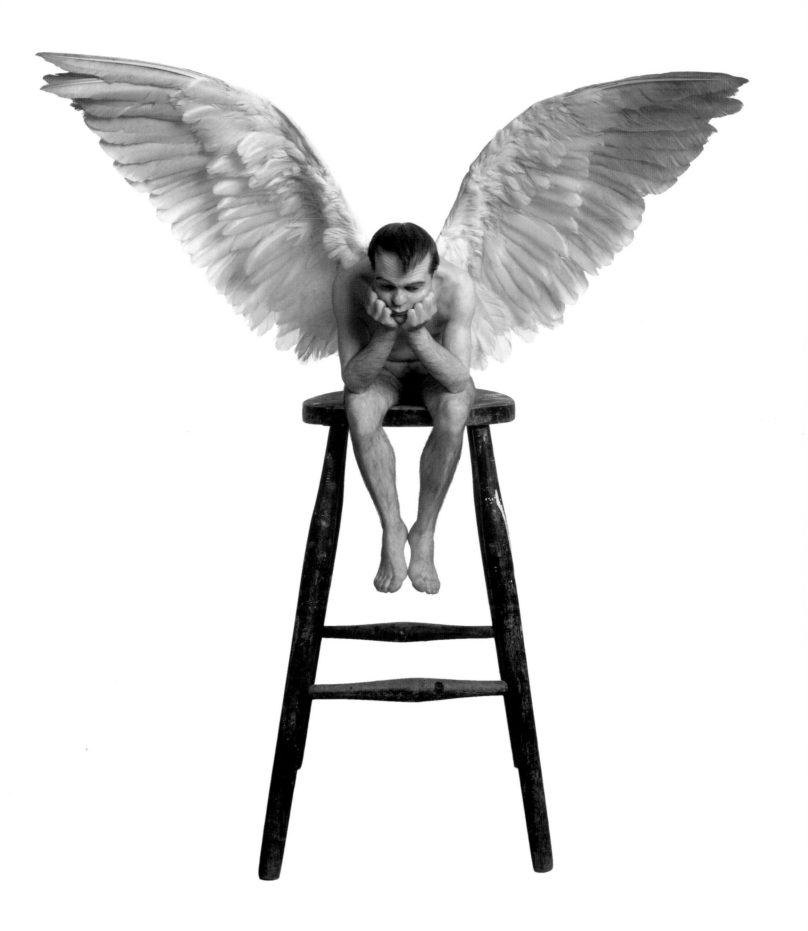

78 RICHARD PATTERSON,
 THE BLUE MINOTAUR, 1996
 oil on canvas, 208 x 312.4cm
 (82 x 123in)

79 **RICHARD PATTERSON,**
 MOTOCROSSER II, 1995
 oil and acrylic on canvas,
 208.3 x 315cm (82 x 124in)

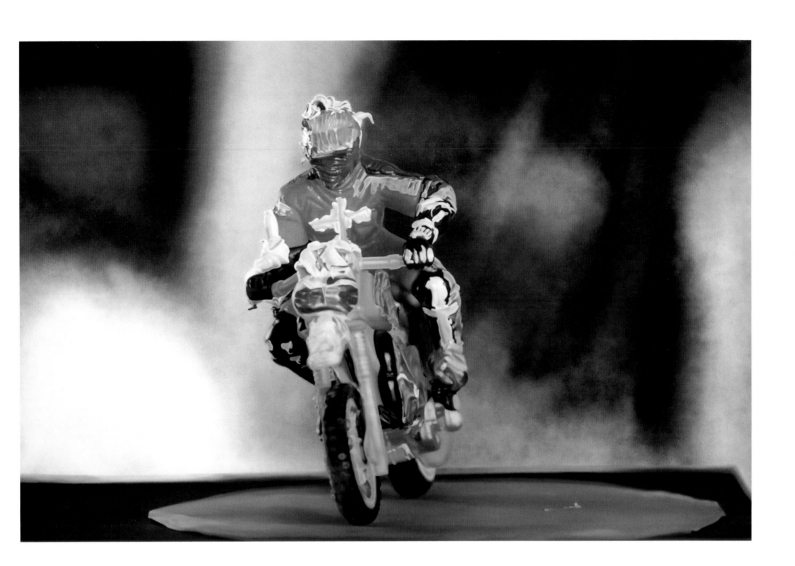

80 RICHARD PATTERSON, CULTURE STATION #2 –
DIRTY PICTURE, 1996
oil on canvas, 213.3 x 427.7cm (84 x 168.4in)

81 DEXTER DALWOOD,
 KURT COBAIN'S GREENHOUSE, 2000
 oil on canvas, 214 x 258cm
 (84.25 x 101.5in)

82 DEXTER DALWOOD,
JACKIE ONASSIS, 2000
oil on canvas, 213.5 x 244.2cm
(84 x 96in)

83 DEXTER DALWOOD,
THE QUEEN'S BEDROOM, 1998
oil on canvas, 193 x 183cm
(76 x 72in)

84 MARTIN MALONEY,
 RAVE (AFTER POUSSIN'S
 TRIUMPH OF PAN), 1997
 oil on canvas, 244 x 457cm (96.06 x 179.92in)

85 **MARTIN MALONEY,**
 EQUAL OPPORTUNITIES, 1999
 oil on canvas, 274.5 x 305cm
 (108 x 120in)

86 MARTIN MALONEY,
 SLADE GARDENS, SW9, 1995
 2001
 vinyl collage, 305 x 792.5cm (120 x 312in)

87 **MARTIN MALONEY,**
HEY GOOD LOOKING
(AFTER POUSSIN'S THE
CHOICE OF HERCULES), 1998
oil on canvas, 245 x 336cm
(96.3 x 132.3in)

88 CECILY BROWN,
HIGH SOCIETY, 1998
oil on linen, 193 x 248.9cm
(76 x 98in)

89 CECILY BROWN,
PYJAMA GAME, 1998
oil on linen, 193 x 248.9cm
(76 x 98in)

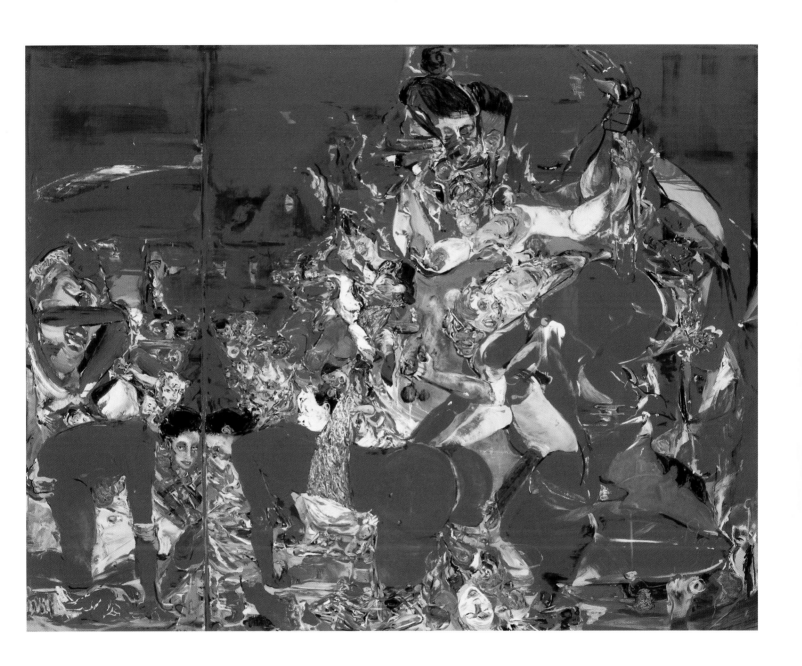

90 CECILY BROWN,
 THE GIRL WHO HAD
 EVERYTHING, 1998
 oil on linen, 254 x 279.4cm
 (100 x 110in)

91 CECILY BROWN,
NIGHT PASSAGE, 1999
oil on linen, 254 x 279.4cm
(100 x 110in)

92 MICHAEL RAEDECKER,
 BEAM, 2000
 acrylic and thread on canvas,
 172 x 203cm (67.75 x 80in)

MICHAEL RAEDECKER,
INS AND OUTS, 2000
acrylic and thread on canvas,
198 x 330cm (80 x 130in)

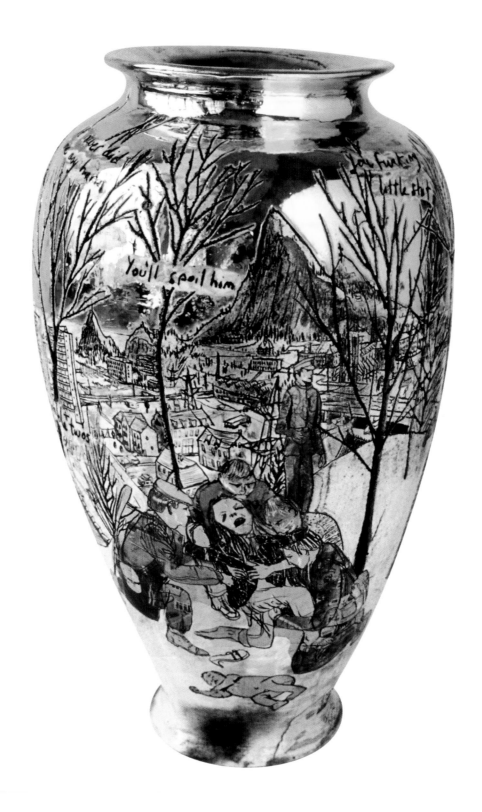

**94 GRAYSON PERRY, WE'VE FOUND
THE BODY OF YOUR CHILD, 2000**
earthenware, 49 x 30 x 30cm
(19.25 x 11.8 x 11.8in)

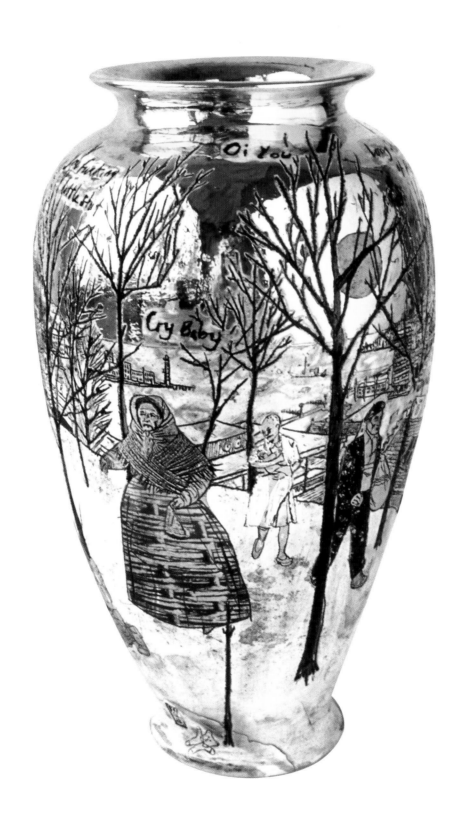

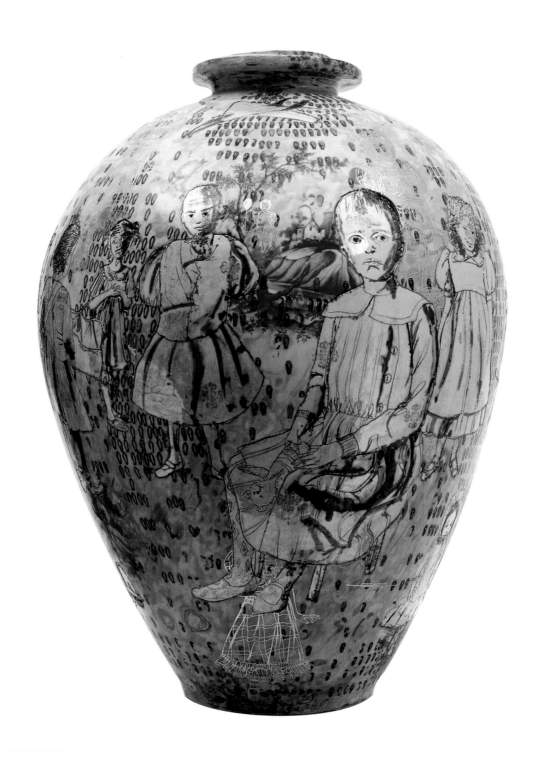

95 GRAYSON PERRY,
 GOLDEN GHOSTS, 2001
 earthenware, 64.7 x 39.4 x 39.4cm
 (25.5 x 15.5 x 15.5in)

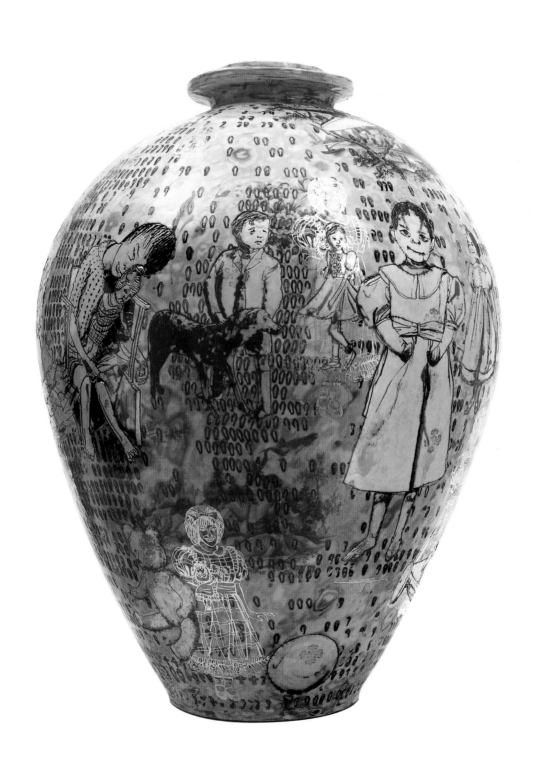

96 TIM NOBLE AND SUE WEBSTER,
MISS UNDERSTOOD & MR MEANOR, 1997
rubbish, slide projector, wood, light sensor,
140 x 70 x 60cm (55 x 27.5 x 23.6in)

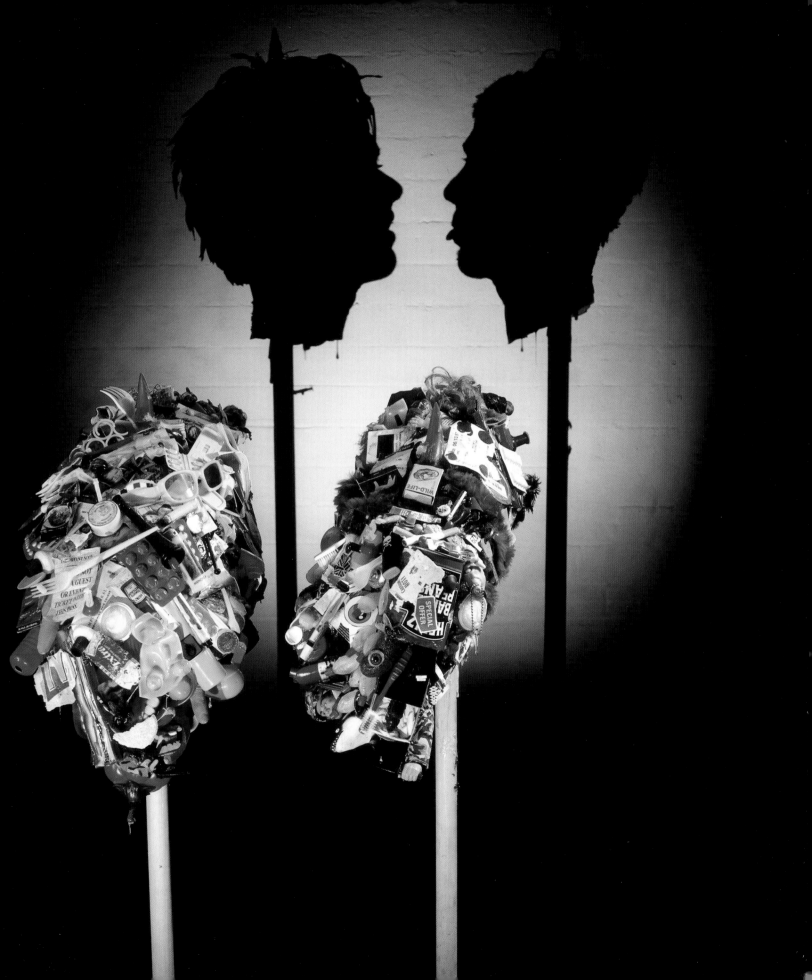

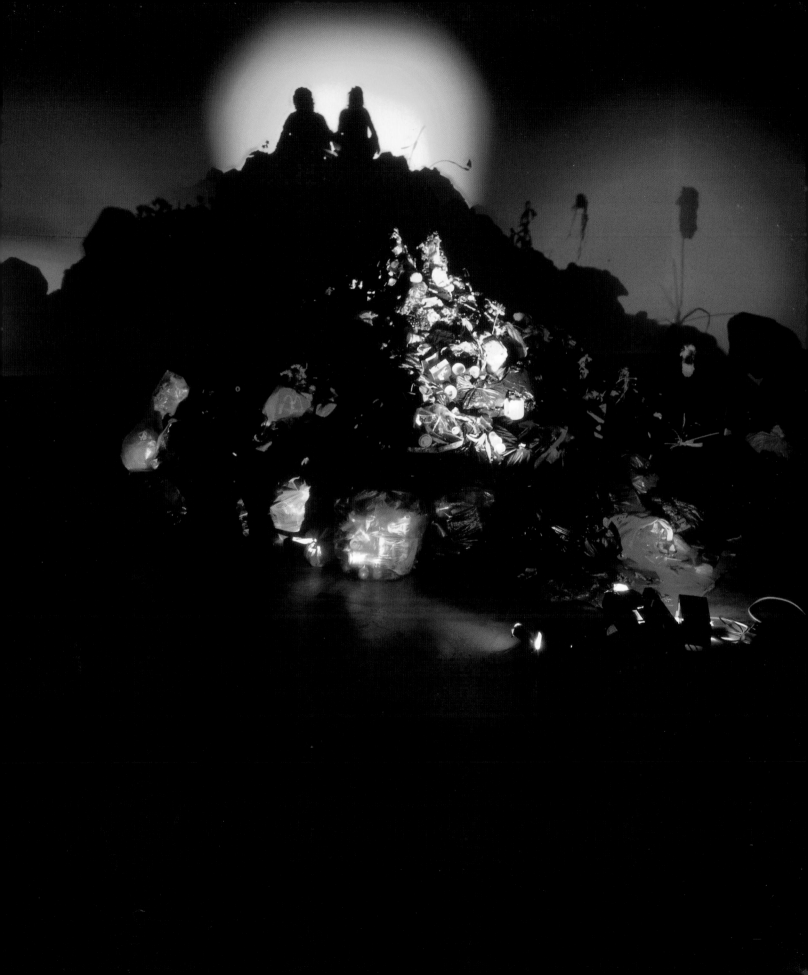

TEXT
PATRICIA ELLIS

It's nice to think of the YBAs as the art world answer to those nineties dot.com whiz-kids – geniuses in their fields with insurmountable imagination and vision, nonconformists, reinventing the terms on which business is done. The YBAs redesigned the idea of 'professionalism'. Work became lifestyle, lofty ideas became personal challenges, equal opportunity meant everything goes, and art was anything that mattered to them. Spawning from the conceptual hothouse art of the eighties – a period largely marked by formalism and a theory-led approach to subject and making – this new generation emerged like a rebellious stepchild on a mission.

It's impossible to define a generation of artists; each one is unique, and their contributions vary enormously. Compare them to what came before, however, and the evidence is overwhelming that something new and improved was going on: art suddenly became hip again. What's talked about most is a working-class ethic, a stream of controversial subject matter, and a DIY approach to masterpiece-making. All this, however, is just symptomatic. The real change has everything to do with intimacy.

WAVE 1 (emerging from 1980s until 1996)
Personal revelation is a ballsy business; it's embarrassing, shameless, poignant, and often tragically funny: Emin's chin-up brave face of a little girl lost, Hirst's sardonic humility of a man contemplating his own demise, Billingham's unconditional love for a self-destructive family. It's not all sap: Turk's wild dreams of becoming an icon, Ofili's funky odes to black heroes, the Chapmans' desire to awe and horrify. And don't be fooled that it's salacious: Doig's paintings and Wilson's sculptures were some of the most important works made during this time, quietly claiming back beauty as a virtue. There's no formal constrictive language, no self-conscious justification for it being Art. The only imperative is it hits a raw nerve. This is art in the real world. These artists make work about themselves and the things which really matter to them, and through that they share a common experience.

WAVE 2 (emerging 1997)
Emerging alongside the original YBA gang, some of these artists were showcased in Sensation, and all bloomed to prominence shortly afterwards. Their work is not distinctly separate from the first group, but rather a continuation of the ideas and possibilities of making art with widespread contemporary relevance. There is a noticeable shift in values, however, as social concerns of the early nineties gave way to a more decadent millennium.

Creating their own fictions, these artists share their opulent fantasies by making affordable placebos for the real thing. It's not at all about celebrity, but rather a glamour of imagination, the ability to conjure the extraordinary and then make it achievable through ordinary means. Dalwood's depictions of famous places as he dreams they might be, Perry's craftwork objects of ultimate luxury, Raedecker's hand-stitched dream homes. Noble and Webster turn their trash aesthetic into rock-star glam, Davies envisions himself in the pantheon of art greatness. It's a different kind of intimacy: sharing a collective dream, not a known reality. For these artists, the physical act of *making* substitutes eighties theory, becoming a New Age gospel based on age-old art tradition. They explore how craft is relevant today. They give genuinely of themselves, making something incredibly beautiful, just to share the experience of it.

In this book, The Saatchi Gallery offers up the key works which transformed how art was thought about, and how it is considered and made today. Its own hip one hundred for contemplation, championship, argument, admiration, and pure viewing pleasure.

98 PETER DAVIES,
TEXT PAINTING (ART I LIKE), 1996
acrylic on canvas, 203 x 254cm (79.9 x 100in)

e most important artist of his generation, Bruce Nauman all that stuff, Mike Kelley he does everything so trashy but we love u to state the obvious big time with such panache, Jean Michel endrix air guitar, Willem de Kooning like you spilt all your nursery m around beautiful, Cy Twombly then you scribbled on the black at looking + tried to rub it out, Picasso he just did whatever the fuck it all together, Bridget Riley so complicated but such eloquent funky results aggression yes please, Rachel Whiteread in contrast such tranquility and d wanted to take over the world don't we all, Peter Halley just what is eels imprisoned or something, Caroll Dunham what a dude! can't believe y mean so much to me, Brice Marden scary monster, Gerhard Richter Police super trooper up yours he's in total control, Joseph Beuys just word for it more like Bugs Bunny, Agnes Martin now that is total terrorvision d that's for dessert blancmange meets Haagen-Daz, Jason Fox megaphone ldy's Kat, Alex Katz its kind of timeless but oh those night scenes, to meet him down a dark alley, Peter Doig ellesse super cool the Brown oh when the saints come marching in repro classics, Sarah Lucas her Louise Bourgeois tough tits she'll rip you to bits, Bernard Cohen kind of all the er dark sheer black magic, Lily Van der Stoker Mutha Fucka, John Baldessari t writing he's like Bruce Springsteen - the boss, Gilbert + George now people say sincere, Antony Caro now he really is one mean badass M.F. us. of Velasquez he's like some Byron/Shelley opium high, Sherrie Levine now that's got to be nyone be bothered to do that shit, Andy Warhol my fucking headmaster now was Josef Albers totally up to date if you want the funkiest thing Gucci could get t, Richard Prince now this really is the greatest thing if ever there was bare it (see the Blue Lagoon), Meg Cranston L.A. style funk + sexiness only with the broom, Matisse he had no problems with some fucker telling him his ical progression but I say this guy is totally radical, Jenny Holzer she's up comedians who always manages to keep a straight face + does loads ke a fucking spoilt brat with his giant dolls + tricks + Run DMC style ow if ever anyone turned a love for Metallica to their advantage, Paul as but he must've seen Texas Chainsaw whilst eating a McDonalds (hello Tom Jones of the art world but I dug that stuff it was really clever, Ellsworth l it leaves me speechless but then I always liked kites, William Tucker S ith "Maybe when your life is close at hand, maybe then you'll understand bird suite ain't that neat, Ashley Bickerton word up Cameo meets Ray Petri, diately what he's on about, Richard Deacon another space case trip he rock steady crew, Larry Clark now that's what I call stream of consciousness Wall he's got an eye for detail look at those fashion statements Dan Graham spiel spiel house + gardens meets Lawnmower man, Barnett 's Acid House, Constable total memorabilia, Juan Miro kind of tasteful rug Fruit + nutcase, Aleksandr Rodchenko kind of art director over design, El Lissitsky cool got better angles more Star Wars, Beat Streuli kind of tia hand it to him, Oskar Kokoshka d'ya think he'd hang with Schnabel g soul rebel, Claes Oldenburg combine harvester a bit of an alien life form, ductiveness, Mitja Tusek kind of the wicked witch of the west, Carl tionalist, Kenny Scharf downright groovy, Chris Burden black humour, Vito Acconi Christian Schumann adolescent swaggering meets P funk, Andreas Gursky kind of ghnut, Bernard Frize left over 60's hippy sentiments with 90's technology, Giuseppe 3 live animals, Thomas Grunfeld dead animals, Meyer Vaisman fake animals, Christoph et the fuck out of my house, Phillip Taaffe control freak, Marina Abramovič

DAMIEN HIRST

Hirst is the alpha-male of contemporary British art. Through his sculptures, installations, paintings, and films, Hirst is constantly re-examining the beauty and poetry in death. Though his work often has a 'hands-off' manufactured aesthetic, Hirst approaches his grandiose subjects with the humility of a man questioning his own existence. He presents a higher truth understood through the mortal limitations of fear, religion, fatalism, awe and humour.

1 Hymn

Twenty feet tall, *Hymn* is a mondo enlargement of Hirst's son's plastic anatomical toy, looming stupid and frightening like the educational tool which ate New York. It's this bad-sci-fi-movie aspect which marks a new turn in his work: Hirst the joker. *Hymn* is like the Wizard of Oz – a makeshift precious bronze god-idol with all its guts exposed.

2 Untitled

Oozing with sickly chocolate-box sweetness, Hirst's *Untitled* is like a big gushy valentine from a psychotic boyfriend. The heart-shaped canvas, poured thick with saccharine pink paint, is a sticky, devouring love trap, a giant fly-strip collection of the corpses of dozens of beautiful butterflies.

3 Holidays/No Feelings

A pill is perfect in form, infinitely impersonal, a non-negotiable power promising a little-longer life. It's a cold-comfort bargain which will default on its contract in the end. Hirst's medicine cabinets offer the first glimpses into his rationalising of sculpture with painting, and philosophy with pop. The impartial ambience of science merges with a more aesthetic reading: the purity of the design of the pills, the clean colour fields of the geometric packaging, the graceful harmony of the text on the labels. Hirst's remedies offer the same comfort as Warhol's soup cans.

4 Argininosuccinic Acid

Hirst's spot paintings are the most pop expression of his work. These groovy polka-dot patterns are a symbol of sixties Brit-lore. Candy-coloured little circles, like mind-expanding tablets, a child-targeted advertisement for self-destructive drug culture and corporate pharmaceutical evils. Their unpronounceable chemical titles indicate Hirst is in the know: the big-daddy pusher of the fun side of death.

5 The Physical Impossibility of Death in the Mind of Someone Living

A seventeen-foot Australian tiger shark is suspended in a glass tank filled with formaldehyde, its predatory viciousness just inches from grasp. Fantastically animate, its frigid stillness is shockingly incomprehensible. Sleek, potent, powerful, *corporate*: it's a trophy of masculine vitality. Hirst presents a Hemingwayesque bravado, the untamed quest of Santiago captured and put on spectacle in a tank.

6 Away From The Flock

Dead animals in tanks filled with formaldehyde, Hirst's sculptures are ready-made still lifes. It's art that actually is nature. A real beast framed is a perfect naturalist representation, surpassing in purity any realistic painting, sculpture or photo. Since their debut in the early nineties Hirst's animals have prompted questions of morality and ethics. Hirst addresses these issues in the sculptures themselves; their subjects are often allegorical to religious, folklore, and social values. Hirst's animals become the preserved remains of martyrs – like the Capuchin monks of Rome, Pompeii victims, even Lenin – displayed for the reminder of greater lessons learned. *Away From The Flock* is an angelically white sheep with pristine fragility, bringing to mind the biblical parable of the lost lamb, and the value of protecting the weak and innocent. Hirst unfortunately translates 'saving' as 'preserving'. In real life wee lambs get eaten by wolves.

7 Some Comfort Gained from the Acceptance of the Inherent Lies in Everything

A cow and a steer are sliced into six pieces each. Mounted in twelve vertical tanks, they are presented in a line, their segments shuffled to create one long, impossible animal facing two directions at once. Hirst presents a physical and spiritual union between partners, a desperate isolation in their merger.

8 This little piggy went to market, this little piggy stayed home

The pig is sliced down the middle, displayed in two separate tanks. Driven on a plinth by motorised pulleys, this dumb animal constantly passes itself in the endless shuffle, a parody of the futile rat race of life.

9 Isolated Elements Swimming in the Same Direction for the Purpose of Understanding

Individually cased, Hirst's fish swim blindly in the same direction without interaction. It's a cold and clinical metaphor for a society without conflict. A utopian ideal of a harmony that comes at an unthinkable cost of sameness and emotional confinement.

10 Love Lost

Like still-life paintings where food and items of luxury are painted as a symbol of the transience of life, Hirst's tanks are also memento mori. In *Love Lost*, a computer sits on a desk. But this is no ordinary office workstation: the chair is exchanged for a gynaecologist's examination seat. On the desk is an empty coffee cup and a watch, referencing the rat race of life and the slow passing of time. *Love Lost,* however, is also a giant aquarium: filled to the top with water, large silver fish swim about in an elation of final rest.

JENNY SAVILLE

Saville's monumental paintings wallow in the glory of expansiveness. There is more of them to love. Saville is a real painter's painter: a Francis Bacon or Lucian Freud for a new generation. The most

impressive aspect of her work is the sheer physicality of it. Saville paints skin with all the subtlety of a Swedish massage: violent, painful, bruising, bone crunching, but it feels so good afterwards. Her figures look like they've been given the ultimate workout treatment: a sumptuous hybrid between Soutine's carcasses of meat and Freud's sex-charged models.

11 Shift and 17 Propped

Saville's ladies are mountains of sumptuous rosy flesh just begging to be climbed, as erotic and breathtaking as virginal Everests. In *Shift* and *Propped*, Saville paints her models with an entrancing exoticism: intimately flirtatious and deeply sensual, their desirability is heightened by their self-absorbed poise. These women know they're arousing, their pleasure is in their own bodies.

12 Fulcrum and 13 Trace

The idea of sinking into the flesh is arousing as B&D. Saville paints visual and psychological penetration. In *Trace*, the constrictive marks left from bra and panties seem as sweetly painful and inciting as a lover's welts; while in *Fulcrum*, three beauties lie hog-tied, a jiggling mass that is more than one man can handle. Saville constructs these paintings with a weighty physicality as if they were sculptures.

14 Plan and 16 Hybrid

Here Saville dissects her models into easy-to-devour chunks for fetishistic fixation. Zoom into: a slightly enlarged breast to inspect closely the tiny highlight on the tip of a nipple, the higher resolution of sin-crimsoned hand with wedding ring, the expansive contoured map of an inviting nether region. Saville breaks her figures down into multiple plains, like Braque or Picasso, to capture every vein and crevice, the secret carnal knowledge of a lover.

15 Host

This is based on the novel *Pig Tales* by Marie Darrieussecq, a story of a woman who finds herself slowly turning into a pig as her libido grows more liberated and gratifying. Saville paints the sensuous belly of a lady-swine, ripe and swollen for suckling.

GLENN BROWN

Brown turns art history into science fiction and vice versa. Making copies of famous paintings, Brown invents his own cloning process. Genetically flawed, Brown's works are based not on the originals themselves, but on reproductions found in books. Each level of reproduction becomes a mutation of the original. Brown's canvases are eerily superhuman: unlike 'real' paintings with all their brush marks and uneven surfaces, Brown's copies are completely smooth, without a trace of human element. Similarly, Brown also paints replicas of the covers of science-fiction novels, turning them into epic landscapes like nineteenth-century American paintings.

18 Dali-Christ

A reproduction of an image of Dali's *Soft Construction With Baked Beans – Premonition of Civil War* painting from 1936, Brown's painting is cannily like the original, but with several alterations. Dali's painting is an almost square canvas (100 x 99cm), with the image seemingly pulled horizontally; Brown radically stretches the picture vertically. Also, Dali's original is done in naturalistic earth tones. Brown uses the acid-tones of digital prints, adds texture and highlights to the sky to create a climactic sunset, and paints in dramatically dark shadows. Through the use of computer editing, and updating the graphics, Brown borrows a master's iconic image and improves it.

19 Ornamental Despair (painted after Chris Foss for Ian Curtis)

Dedicated to the tragic Joy Division frontman, there's something about a crippled planet being towed futilely across an infinity of cold empty space that would appeal to him. The title is also borrowed from a Julian Schnabel painting which uses a detail from the band's album cover. Brown's painting is a copy of a poster by sci-fi illustration guru Chris Foss. Painted mirror image to the original, he further distorts the reproduction process – a backwards image is a common error in publishing which Brown adapts to painting. Three metres long, Brown's painting turns a kitsch commodity into something grandiose and authoritative. A historical painting of a bygone idea of a future which never came to exist.

JAKE AND DINOS CHAPMAN

Jake and Dinos Chapman lie awake at night, dreaming up a nation's nightmares. Exiled in a self-made world of teen boy gross-out contests, the brothers constantly up the ante on doom through a never-ending source of DIY special effects. It's the plausibility of it all which makes it so effective. The Chapmans reflect contemporary thought by taking the headlines to their ultimate conclusion: genetic modification, nuclear war, cultural holocaust, anti-capitalism. The most disturbing thing about the Chapmans isn't the violence, or the cynicism, or the outright perverted: it's the looming question of What If?

20 DNA Zygotic

The Chapmans' sculptures of mutated children are possible by-products of gene tampering, nuclear spills or cloning experiments gone horribly awry. Whatever the evil, it's not the children's fault: they're placid, angelic creatures who seem not to notice that they have four legs, or twelve heads, or genitals for a face. If they're disturbing, that's the viewer's hang-up. The children themselves seem to relish their strange beauty, know that they're one-of-a-kind: each one having been made by hand in the artists' studio.

21 Tragic Anatomies

This is an artificial Eden constructed from AstroTurf and catalogue-order plastic plants, populated by conjoined nymphs designed for the sole purpose of onanistic gratification. This isn't Hieronymus Bosch does Genesis, but rather two men dreaming up the beginning of the world as they would have preferred it.

22 Zygotic Acceleration, Biogenetic, Desublimated Libidinal Model (Enlarged X 1000)

Here the Chapmans take aim at the world of advertising. A team of pre-teen 'girls' osmose in a bizarre, sexualised fashion orgy. Their genital-less bodies melt into each other, creating a single hermaphroditic torso. This is the world of department-store mannequins: gracefully posed, glossy and dead. All similar, but inherently unique, their faces (some angelic, others distorted like porn blow-up dolls) read like a celebration of image marketing and globalism, pointing to an underlying corruption: this piece uses the same moralistic strategies of a Benetton poster. Black Fila sneakers suggest perhaps a death squad.

23 Great Deeds Against the Dead

It's hardly surprising that the Chapmans would choose as their mentor the nineteenth-century Spanish painter Francisco Goya; the great chronicler of the Peninsular War, whose works became progressively tortured through his dementia-infused demise from syphilis. *Great Deeds* is a sculptural interpretation of one of Goya's etchings: a life-sized hanging tree, hung with dismembered mannequins. The Chapmans literally play with history: they remake it in plastic. Like a big toy.

24 Disasters of War

Goya's *Disasters of War* etchings capture every horror imaginable; they show a real-life hell on earth in a contemporary era. The Chapmans' versions of these works are true to every detail: hand-tinted etchings, they have the air of historical authenticity and a certain stylistic semblance. The Chapmans, however, re-create their *Disasters of War* in high-school drop-out style. Delinquently scratched like toilet-stall graffiti, their images are comic depictions of terror, reminiscent of heavy metal album covers.

25 Hell

Comprising nine giant terrariums laid out in the shape of a swastika, the Chapmans' *Hell* is a hobbyists' *Apocalypse Now*. It took two years to create; hundreds of tiny trees and rocks purchased from model shops make up perfectly miniaturised landscapes inhabited by over 5,000 figures (each one cast and hand-painted). This could be Verdun, or Vietnam, or somewhere a lot closer to home. It's a lads' war game learned from movies and Xbox. By reconstructing Hell in miniature, they replicate the detached experience of watching real evil through the compact window of a television screen. The Chapmans place the viewers in the position of ruthless gods, looking on with awe and wonder at the destruction they've willed.

26 The Chapman Family Collection

The Great White Hunter story is the swarthy backbone of British lore. *The Chapman Family Collection* consists of thirty-four tribal fetishes, displayed in Victorian museum fashion in a classist piss-take. These totems are a nineteenth-century logoism of imperialism, trophies from the extermination of an ancient inferior race. More disturbing still: all these ju-jus oddly look like stuff from McDonald's.

CHRIS OFILI

Ofili's paintings are psychedelic patterns made from layers of tiny dots, weaving a junkie high around collaged images cropped from magazines. Ofili often incorporates elephant shit, a trademark of his early work, as a three-dimensional aspect to his paintings, as well as making sculptures from piles of boulder-like dung. Authoring a hip and trendy chapter to Eurocentric art history, Ofili brings questions of ethnic and male identity into the pop-cultural realm. Using the language of hip-hop music, blaxploitation films and black-power logoism, Ofili paints from his own experience. He makes the kind of work he'd most like to see, the kind of paintings which have never existed before. He's creating a new art history on his terms.

27 The Holy Virgin Mary

So much for fair-haired Italian divas: Ofili's virgin is a black woman in African dress. She's got all the trademarks of Renaissance painting: the blue robes, the illusion of gold-leaf background, a scratchy halo like some kind of electrical static sparking from her head. Ofili's Holy Mother isn't the divine image of virtue; surrounded by porn and temptation, she's a tough disciplinarian, a no-nonsense single mum who'll bring 'em up right no matter what the cost; and that's as saintly as it gets.

28 Afrodizzia and 29 Afrobluff

Ofili celebrates black history. Gorgeously textured surfaces incorporate the colours and patterns of African textiles, glammed up to be funkadelic. Incorporating hundreds of faces cut from magazines, he offers up a collection of role models too numerous to count, all adorned with ridiculously large mock-'fros. These paintings read like a heaven full of stars, signposted by globs of elephant dung decorated with the names of heroes righteous and cool: Cassius Clay, Miles Davis, Shaft.

30 Four Plus One More

Named after the rap group Funky Four Plus One More, Ofili's woman is an earth-mother party diva. Painted in muted brown tones, she's reminiscent of work by Picasso or Matisse. Ofili reappropriates the masters' cultural hijacking, while at the same time engaging in a little remix of his own.

SARAH LUCAS

Lucas constructs a downtrodden feminism, based on a working-class salt-of-the-earthiness. Writing a low-life vernacular in 3-D, her work explores the nature of relationships, sexuality and self-esteem, through ready-made assemblages. Her girl-power *Carry On*-ish one-liners mask a gritty realism of female experience. Lucas chooses her materials as carefully as a painter chooses a gesture: each item as damaged and disposable, or perversely luxurious, as her image requires. Her assemblages are substitutes for people, each with an inherent personality of its own. Literally objectified, they are less-than-human targets for sadistic role play.

31 Self-Portrait With Fried Eggs,
She's seated in a makeshift 'kitchen', looking tired, confrontational and a bit desperate; but it doesn't matter. All that's noticed is her fried-egg tits.

32 Sod You Gits
A ready-made portrait painting: a photocopy of a spread in the UK's most salacious tabloid. The headline feature's about a midget stripper, her 'success' story repeatedly phrased like some circus sideshow attraction drooling over the real sadness of her situation. 'The Penguin', as she's repeatedly called, is a real-life version of one of Lucas's sculptures: a tough cookie getting eaten alive in a cruel world.

33 Two Fried Eggs and a Kebab
Lucas's sculpture is a right slapper. Expansive on the table top, she's flat as a board, nothing to offer but some wobbly fried-egg tits and a bit of cold lardy snatch. Stunned and stupid, her face is a photographic replica of her body: vacant cheap sex, an object for public use, gaping in anger, fear and surprise. Lucas doesn't present the usual chipper 'dolly-bird' stereotype. Hers is a pathetic wench, the humorous object of bullying, the wasted victim of a borderline violence.

34 Au Naturel
The empty shuck of an instantly recognisable image: the filthy mattress, the old tin bucket, droopy melons, the requisite six inches of cucumber protruding hungrily from an unsavoury stain. Welcome to married life. A hollow shell of easy comfort and habitual relegation, fat with make-do satisfaction and occasionally pondered dreams of what-could-have-been. Domestic objects, uncanny and banal, stand in for a passion so thoroughly ploughed there's not a hint of intrigue left: only the well-practised compliance of tolerating each other's nose picking and silent farts.

35 Dreams Go Up In Smoke
When Lucas quit smoking the end result was torturous penance: months and months of coating various objects – from a vacuum cleaner to a burnt-out car – in Marlboro cigarettes. *Dreams Go Up In Smoke* is a serious thrift-shop find: original seventies mojo gear of a particularly virile horned demon with requisite big-buxomed rider. Lucas coats the beast's lower realm like a tobacco-sponsored mermaid; white-trash desires puffing away until they're gone.

36 Bunny
Lucas's *Bunny* reclines, too exhausted to be sexy, on the men's club chair, legs habitually splayed, ears flopped in acquiescence, sultry and grey with the saturation of cigar smoke and bourbon stench at closing time. There's a humour in Lucas's pathos: because she's got the camp of a washed-out Marlene Dietrich drag queen, because she's an affable working girl punching in seedy overtime, because she doesn't seem to mind. Because she's just a well-stuffed pair of pantyhose. Guiltily, she's desirable anyway.

37 Human Toilet
Lucas sits naked on the can, holding the cistern, becoming a *Human Toilet*. The receptacle of every bit of piss, shit and puke which comes her way.

38 Chicken Knickers
She straps a plump juicy butterball to her pants, reducing herself to a piece of meat – raw, gaping, cold – provoking an instinctive desire to fuck it. Lucas presents these images as photos, like cherished pin-up posters of a girlfriend and all the reasons she's loved.

RICHARD BILLINGHAM
Billingham uses photography to capture traditional painterly scenes in contemporary environments, such as landscapes, working-class suburbs and, of course, his home. Billingham's photos of his family are the original fly-on-the-wall documentary, an *Osbournes* for the nineties. Meet Ray, the crumbling alcoholic shell of the man he used to be; Liz, the overweight, tattooed tour de force of a mother with a fairy-princess passion for all things cute and decorative; Jason, the younger brother: out-of-control baby-father with a penchant for video games and mind-altering drugs; and Richard, invisible behind the camera. Seeing the Billinghams up-close and personal, it's impossible to be judgemental. A family no different from millions of others: it's a dysfunctional unit that actually works. Through the trials and tribulations of their daily lives, they share themselves: interacting, relaxing, arguing, supporting and caring. Taken between 1990 and 1996, these are intimate memoirs of a family the artist loves.

39 Untitled (Cat)
Perhaps Billingham's most iconic image, this photo of Ray and the family cat is a scream. Taking its cue from surrealism, it's a one-in-a-million shot: cat frozen spastically in mid-air, Ray frozen spastically in mid-chair. The subtle suggestion of violence loans an extra pleasure: it's only logical that the animal is jumping from the cupboard, but there's still a harboured glee for the possibility of cat-as-projectile-weapon innovation, a little domestic action all in good fun.

40 Untitled (Dinner)
Billingham's photographs have an inextricable link to painting. He chooses his subjects carefully from art history: classic compositions and poses of people, flower patterns, animals, food – all the traditional painting props. His parents' chintz interior decor mirrors strangely the busy wallpapers and carpets in historical paintings. Seeing this photo of Ray and Liz eating, it's easy to think of countless banquet scenes starring ancient royals with their meaty feasts and mangy dogs. Billingham snaps his parents doing the contemporary version: sofa dinner shared in silent solitude. Engrossed in their own thoughts, close comfort is often like being worlds apart.

TRACEY EMIN

Influenced by talk-show television and tell-all exclusives, Emin uses mass-media strategies in a folkloristic tradition of storytelling. Playing both subject and therapist, she reveals and edits her autobiography. Emin has become a living artwork, achieving a celebrity status just for being herself. Every time she appears in newspapers and on the telly, she is essentially making the 'non-art' world compliant participators in her practice. Emin also tells her story through drawings, sculptures and installations. Craft-based, usually laboriously incorporating sewing and text, each piece is an intimate home-made offering of herself. Her works operate like souvenirs, celebratory memoirs of the occasion of her life.

41 Everyone I Have Ever Slept With 1963–1995

Invited to participate in her first high-profile show by her curator boyfriend, Emin embroidered her portable bedroom with the names of every person she'd ever slept with – including the curator's. In her list of bed partners, she's also included familial and platonic relationships. This piece is pivotal in the indexing of Emin's autobiography, as it introduced a cast of characters which would later play major roles in Emin's unfolding stories.

42 My Bed

Creating headline news during the 1999 Turner Prize, Emin showed her bed, in all its embarrassing glory. Empty booze bottles, fag butts, stained sheets, worn panties: the bloody aftermath of a nervous breakdown. By presenting her bed as art, Emin shares her most personal space, revealing she's as insecure and imperfect as the rest of the world.

43 Exorcism of the Last Painting I Ever Made

In 1974, Joseph Beuys did a performance called *I Love America, and America Loves Me* where he lived in a gallery with a wild coyote for seven days as a symbolic act of reconciliation with nature. In 1996, Emin lived in a locked room in a gallery for fourteen days, with nothing but a lot of empty canvases and art materials, in an attempt to reconcile herself with painting. Viewed through a series of wide-angle lenses embedded in the walls, Emin could be watched, stark naked, shaking off her painting demons. Starting by making images like the artists she really admired (i.e. Egon Schiele, Edvard Munch, Yves Klein), Emin's two-week art-therapy session resulted in a massive outpouring of autobiographical images, and the discovery of a style all her own. The room was extracted in its entirety, and now exists as an installation work.

44, 45, 46 and 47 Four Blankets

Craftwork presents a simplicity and security not often associated with sensation. Through the action of 'sewing' out her stories, Emin adds an extra personal touch to her work, making it more believable and genuine. She is literally spinning the yarn of her life: ancient diary entries, love letters, childhood memories, conversations she's never forgotten. It's storytelling in the tradition of folk art, patching security blankets for healing and nurture.

48 I've Got It All

Emin is almost always portrayed as a Diana-esque *femme tragique*. It's rare to get a glimpse of the happy, successful, confident person she's become. *I've Got It All* is a transient crowning glory: a shameless, two fingers up to her critics. Emin's triumphed over all, and has money up the wazoo to boot!

49 The Last Thing I Said To You Is Don't Leave Me Here

When not making art in their makeshift store in London's East End, Emin and Sarah Lucas would often take weekend breaks to Whitstable. Here they would camp out and party in public beach shacks. When the huts were scheduled to be torn down by the city, Emin bought one. It's her own personal monument to her youth.

PETER DOIG

Doig makes simply exquisite paintings. He captures an old-time simplicity in his images – like Van Gogh or Monet – harking back to a time when irony had no place in art. This folky quality makes Doig's simplicity deceiving. A snowfall made up of every conceivable colour, a red line for a stick slashing through a blue lake, a green forest composed of a watery stain: these are devices introduced by artists like Cézanne, Barnett Newman, Marc Rothko. Doig manipulates nature into art. He uses paint to render the things he finds beautiful, in a way that it can't be seen in real life.

50 Snowballed Boy

This Norman Rockwellesque scene is a footnote from an ideal childhood. Watery blue and pink lines crackling across the ground give the perfect illusion of well-trodden snow. The trees against the white northern sky are a wispy vermilion web, the rickety lines of the snowfence are almost a non-colour, dirty and weathered with a hint of everything on his palette. Doig renders all of these with a faded nostalgic charm, then violently attacks it with bright white snowball splotches. He invisibly paints the viewer into the scene as the incriminated snowballer.

51 The Architect's Home in the Ravine

Plainly in view but physically inaccessible, Doig half obliterates his *Architect's Home* with an underbrush as dense as a half-finished Pollock. The scene becomes foreboding: something out of an Edward Hopper or Andrew Wyeth painting. With all the richness of the distant woods and the stunning architecture to look at, it's the twigs which steal the show. Doig's painting reinvents the way a picture is meant to be looked at.

52 White Canoe

Doig paints white like it's got every colour in it; he paints dark like it's got every colour *on* it. A mirrored image of a lake at night, *White Canoe* is a wishful infeasibility where the reflection is more detailed than the landscape itself. The boat is aberrantly glowing. The landscape has the all-consuming blackness of an oil slick, deafening and motionless. All other colours seem to slide across it in a rustic laser show. The blue stains of tranquil moonlight have the eerie effect of erasing; Doig's perfect night seems to be melting like celluloid stuck in the projector.

GARY HUME

Hume makes a brand of painting which is barely painting at all. It's more like image architecture based on blocks of colour. Rich lacquer on sleek metal sheeting draws out minimalist images: girls, flowers, abstract patterns. It's a process based in graphic design – time spent planning the perfect image, choosing each colour in advance, knowing and feeling a space before it happens. Hume's process is immediate: there is no room for experimentation or error. He makes instantaneous 'paintings' for instantaneous gratification.

53 Vicious

Hume's *Vicious* could be predator or prey, prowling through the dark Warholian jungle. It's the double perspective of this painting which adds to the anxious confusion: the figure is running both forward and away at the same time. The dull brown mass of the body recesses against the vibrant black and yellow, the subject shiftily becomes the background to the negative space.

54 Begging For It

This is a Renaissance painting in its bare essence, streamlined for contemporary worship. An androgynous silhouette is poured out in pure crisp colours reminiscent of Raphael. The black sinister hands strike through the pastoral calm in empty consumer prayer, like a Madonna in fetish gear.

55 Four Doors

Simplified life-sized hospital doors are rendered with simplistic graphics and institutional colours, like a representational Mondrian. Painted on to flat sheets of MDF, *Four Doors* promises an impossible entry. Instead their flatness offers the beauty of a defunct ideal, a symbol of fear, the portals between life and death.

SIMON PATTERSON

Patterson's brain operates like a fuzzy-logic computer, making incongruous connections between thought and images. Photographs of a famous Capability Brown park, obliterated by neon-coloured clouds exploding from army-supply smoke grenades, become real-life painted landscapes. Photos of a man-lifting kite – the kind that could have been used to cross from East Germany to the West – symbolise failed escape. Labelled 'Yuri Gagarin', it lies mangled, caught in a tree in one photo, smashed into a building in another. Patterson offers a personal vision of a world where images are substitutes for language, and language is stripped of its logic. It's a crash course in semiotics for the MTV generation.

56 Great Bear

Patterson maps out a foolproof user-guide for postmodern thinking. Like the Tube map itself, Patterson's *Great Bear* is an abstraction: actual distance and direction is irrelevant to any known topography. Start with Chinese revolutionary leader Deng Xiaoping and change at Napoleon for Thirties Comedians. Get off at Leonardo da Vinci (one station past Mel Brooks). Then take any combination of journalists, film stars, footballers, explorers and engineers until you get to the saints train. Get off at St Aidan for domestic flights, and St Anthony & St Augustus for international destinations. By far the best way to get from West Ham to Heathrow.

RICHARD WILSON

Wilson makes installations, site-specific projects and structural interventions. Working from his interest in architecture, engineering and monumental feats, Wilson uses the individual information of each place for which his work is intended to create new spatial experiences. He plans his ideas in drawings and models, which also exist as art works in themselves. Wilson has several permanent installations in the UK, such as a cross-section of a ship which appears to 'float' on the bank of the Thames near the Millennium Dome; and *Over Easy* at the Arc in Stockton-on-Tees, where a large disc containing windows has been engineered into the wall. Oscillating 300 degrees, as the disc turns it slowly reveals the internal construction of the building and the activities within.

57 20:50

20:50 fills a room waist-high with recycled engine oil. Its mirrored surface encases the gallery like a space-age architecture, greedily receiving the perfectly crisp reflections of everything it sees. Sliced through with a precision-placed walkway, the installation invites the viewer to venture in. The exact replication of the room in mirror image can only be viewed from the end of the plank. It's the definitive point in the middle of a symmetrical plane.

RACHEL WHITEREAD

Whiteread makes physical objects of the invisible. *House* recast the entire three-floor interior of a semi-detached terrace dwelling in east London. Filling up the building with cement, then tearing the structure down around the concrete filling, left a monumental skeleton of a domestic space. Whiteread's cast objects place the viewer in the position of the original structure. She offers a detailed view of solid 'air', constricted and scarred with the textural impressions of wallpaper, wood, metal, rust. Her works operate as phantoms hanging silently back, rock-solid monuments of things gone unnoticed.

58 Ghost

Like a minimalist sculpture by Richard Serra or Donald Judd, *Ghost* is a massive concrete block. But something else is familiar. Within the gridlines of the casting seams, there are the delicate traces of architectural details: the door, the skirting boards, the protrusion of what once was a fireplace, still marked by the soot of a long-dead hearth within. This is the perfectly preserved interior of a living room, the remnants of cosy domestic life turned into a tomb.

59 Untitled (Bath)

Whiteread's baths are visual tricks: the negative space of a tub becomes another tub. There's no challenge to the discovery of the object, no allusion to a narrative. Instead, Whiteread plays with an idea of function and form: presenting a familiar object, stripped of its original purpose, *Bath* becomes purely abstract, a contemplation of the empty space surrounding an intimate place.

60 Untitled (Orange Bath)

Here, she uses the colour and substance of her material to completely alter the meaning. Cast from a translucent flesh-coloured resin, the bath takes on a life of its own. The sculpture seems to come alive like a skin, with a glowing force singing from within. The tub is no longer a tub, but a sensuous groove, an object of sexual fetish.

71 Untitled (One Hundred Spaces)

This installation fills a gallery with a gridlike placing of what at first seem to be giant candy lozenges. On closer inspection, Whiteread's sweets are blocks of highly toxic resin, cast from the spaces underneath chairs, lined up like the remnants of a strictly ordered classroom. It's a disturbing fascist ideal: each one glowing and special, empty plinths waiting to support the brighter future of an institutionalised tomorrow.

GAVIN TURK

For Turk, things are not always what they seem. Turk makes fakes. Fake celebrities, fake objects, fake history. For his degree show at the Royal College of Art he made a replica of the English Heritage plaques which map out landmarks throughout London. By making his own eulogy, Turk presented himself as a national treasure, a genius yet to happen. In this context of artist-as-icon, Turk controls his ersatz world of surrogates. As in restaurants that boast 'Elvis Ate Here', Turk realised it's the rumour and plausibility that surround the art that count, reality has nothing to do with it.

61 Death of Che

Re-creating in sculpture the famous photo of the murdered body of Che Guevara, Turk casts himself in the martyr's image. Dusty and deathly pale, Turk spares no detail in the realism – from the re-creation of the cistern base to the insertion of each individual hair on the sculpture's legs. Guevara's guerrilla-chic coif was professionally styled to order by a top Soho salon. Placing himself in the role of martyred hero, it's the duplicity of Guevara's image which intrigues him most: Guevara was an almost religious Christlike figure transmuted to commodified idol, a political rebel who in death was posed to look like his own iconic portrait so that he might be identified.

62 Nomad

As well as making self-portraits, Turk also makes too-believable replicas of common objects. Garbage bags and empty cardboard boxes, weightless trash cast in bronze and painted to look exactly like the real thing. Turk's high-art litter forces a reconsideration of beauty. *Nomad*, at first glance, is the fragile cocoon of a homeless person, one of dozens found camping near the artist's London studio. It's only its lack of occasional movement that suggests this isn't a person at all, but rather a block of metal; a *trompe l'oeil* of destitution cast in the media of immortality.

63 Pop

A life-sized self-portrait: Turk is Sid Vicious as Elvis Presley. In Turk's world of product substitutes, even celebrities are exchangeable; one is as good as the next. Being a sex symbol is a generic occupation, the attributes the same: young, renegade, macho guys in eyeliner, with puppy-dog sneers. It's a tool celebrities themselves use – Sid Vicious was the prince to The King. Turk re-creates the punk star's famous scene from 'My Way' (itself a Sinatra song covered by Elvis, Sinatra being one of Elvis's later idols), posed as Andy Warhol's *Double Elvis* painting. Turk revels in Vicious's on-screen identity crisis – he wants to be a somebody who's everybody too.

MAT COLLISHAW

Collishaw rewrites a pastoral myth of history and technology underlaid with uncompromising violence. Alongside his photographic work, Collishaw also works with film projected on to glass, maquettes and furniture. Tiny images of homeless people flicker on to snow bubbles, an apparition of a modern-day remake of Géricault's *Raft of the Medusa* floats ghost-like in a rum bottle, the film *Ultraviolet Baby* shows an infant glowing like a modern-day Christ child beneath the anti-heroin lights in a public toilet. He incorporates Victorian photographic techniques and ephemera into a newfangled mysticism. It's the occultism of the medium that interests him: he's forever taking images apart to find their soul.

64 Bullet Hole

This is one large photo made up of fifteen frames, fragmented like the panes of a stained-glass window. At first glance, it's unreadable, like an abstract painting. Then an image registers: a gaping vagina. It's only with the full realisation that this is a close-up of a head wound (taken from a pathology textbook) that the layering becomes complete: there's a religious beauty and animal sexuality in something so abhorrent.

67 Coronna and 68 Madonna

These works have a historically epic quality. Coronna disturbingly implies early twentieth-century experimentation, *Madonna*'s timeless face is cropped from a photograph of an Indian woman taken after her village was destroyed in a flood. These tragic images seem all too contemporary with their digitised high-gloss finish. However, their surfaces aren't photographs at all; rather, they're made up of tiny, cold ceramic tiles. In a complex process of construction, Collishaw pixelated his source material on a computer, and then ran it through a specialist program to identify each pixel as one of the forty-five shades of white, grey and black of the tiles. A giant plan was then produced as a 'paint by number' and the tiles were individually applied according to code. Collishaw uses mosaic to immortalise his subjects in the same way images of saints and martyrs were rendered in early churches, but by doing so he replicates the process of image transmission over the Internet.

MARCUS HARVEY

Harvey paints the pornographic. Brutal pin-ups of tawdry girls, the famous portrait of child-murderer Myra and, more recently, steamy peeping-tom views and still lifes of Ann Summers' party aftermaths. Harvey works from 'amateur' photographs – both found images and photos he's taken of scenes he sets up. Stylistically ranging from expressionism to realism, Harvey's paintings are highly decorative surfaces which break down image components, creating 'secondary' images or abstracts, elevating cultural 'smut' to high art. Through the process of painting, Harvey pushes the boundaries of how far an image can be manipulated before it loses its original meaning.

65 Julie From Hull

In his early work, Harvey took as his muses the home-porn photos of readers' wives from the back pages of raunchy mags. Violent blurs of colour set the ground for a savage eroticism, while ornamental patterns lend a sense of high-class design; the women themselves are secondary to the ambience, represented as slick vixens only by a thin black-line graphic. It's a lewd blend of Courbet meets Patrick Caulfield. *Julie From Hull* operates in the genre of nineteenth-century parlour paintings; high art as a dignified excuse for lecherous gratification.

66 Myra

Harvey's painting of Myra Hindley is shocking: a monumental portrait of a heinous, yet pretty, serial killer. Harvey renders his copy of her famous picture with unsettling clarity: the pixelated newspaper texture is created by the tiny handprints of children – a million innocent testimonies to pure evil. Harvey's painting, however, isn't concerned with moral implications: this is a painting about a nation's obsession with an iconic snapshot of a femme fatale.

MARC QUINN

Quinn makes work about the passing of time, the inevitability of death and the beauty in the cyclical structure of nature. Often using his own body as both subject, and matter, he's shocked the world with such pieces as his blood head and flayed skin. His more recent work, however, includes marble sculptures of disabled people done in heroic fascist style, and large arrangements of cut flowers cryogenised in giant tanks: moments of unblemished bloom, frozen for ever in the exact moment between life and death.

69 No Visible Means of Escape

When painting *The Last Judgement* mural in the Sistine Chapel, Michelangelo snuck his own image into the scene – as the flayed skin of St Bartholomew. Marc Quinn's *No Visible Means of Escape* is a cover version of this classic. A husk cast from his own body hangs grotesquely fresh-looking in the gallery. But there is a certain allure in it as well: pain as an aesthetic pleasure. Quinn presents a carnal spiritualism, an ecstasy of flagellation and a crooked sense of humour: he's literally giving the skin off his back.

70 Self

This is a real self-portrait. It's genuinely the artist that's being looked at. Cast from a mould of his own head, Quinn's bust is a solid block of his own blood, permanently frozen in a customised refrigeration unit. Quinn brings into question art and science: what constitutes an ideal, and what will be the future of representation. With developments in DNA cloning, in years to come it will be possible not only to look on this image of Quinn – but also to reconstruct him in his entirety.

RON MUECK

Creating super-real sculptures of the people he knows and loves, Mueck sums up those life-altering realisations which can't be described in words. Working in rubber and polyester resin, he renders his figures with exact detail – with one exception: scale. Through enlarging or shrinking his sculptures, he's changing the physical presence of the viewer, altering their perception and relationship with his characters, forcing them to reflect on their own lives and celebrate the fantastic humanity in it all.

73 Dead Dad

There comes a moment of reckoning when the realisation dawns that parents are just people – with faults, needs and weaknesses of their own. It's a pivotal occasion: the shattering of an idol, the realisation that that pillar of support wields no special power. Mueck's *Dead Dad* is a crucial Willie Loman moment: a portrait of a man, only one metre in length, laid out naked on the floor. Mueck offers only the quiet contemplation of a man, and everything he was, so much smaller than remembered.

74 Mask

It's no wonder babies scream. *Mask* glowers hard like a long-forgotten guilt complex. Mueck presents a parental figure larger than life; or rather the exact scale to make the viewer feel like a frightened child looking up at an irate adult. Or the viewer looking up at the artist: this piece is an unnerving self-portrait.

75 Pinocchio

A tiny, gangly, tousle-haired lad, with itsy-bitsy Y-fronts and the most devilish glint in his eye, *Pinocchio* is irresistible. He's the imp of children's fables, a wee Tom Sawyer in the making. He's the manipulative propagator of a thousand curses, a loveable adventurer with ways and means to win over even the coldest heart.

76 Big Baby

Everyone talks about the pride of beholding their child. It's the biggest thing that will ever happen in life. Especially if the baby is the size of a gorilla. Just think of the milk bills, household damage, the lifestyle redesign – the diapers. Mueck's *Big Baby* brings parents down to size; those natural feelings of uncertainty, overwhelming responsibility, the oh-my-God what-have-I-done invariably creep in. By a process of simple enlargement, Mueck sums up every wonderful crazy emotion of parenting into one single viewing experience. She's just beautiful.

77 Angel

A wee guardian angel – just a regular bloke really, a next-door neighbour kind of guy – is perched, bored, on a small life-sized stool. As he looks down on mere mortals below, all must be going well as there's no work to do.

RICHARD PATTERSON

Patterson's paintings of collages operate like movies or portals into a parallel world. His works have both the illusionary space of a fragmented canvas, and also the conceptual space between images – the associations the viewer makes from each selection, and the visual and mental 'delays' which occur in the image seams. By mixing photorealistic painting style with gusto-infused abstraction and meditative colour fields, Patterson's paintings begin to act like film. Images are cropped, edited and reassembled so they visually speed up, slow down and pause. He present narratives which seem to have 'real' time.

78 The Blue Minotaur

Painted with advertising glossiness as if it were airbrushed, it's almost like a digital animation. The scene's a simple one, a plastic toy come to life, standing on the edge of a platform looking into another world, a contemporary play on the myth of the trapped Minotaur. With this painting, Patterson shows that this is only an invention: the strip along the right side of the canvas recedes like the blurred space of a background in a photograph. All of Patterson's paintings are abstractions of photos he takes of assemblages he's made in his studio – sometimes of advertisements or paintings, sometimes of sculptural compilations. Through the abstraction process of painting them, he creates completely believable scenes which otherwise could not exist.

79 Motocrosser II

A contemporary image executed in timeless medium *Motocrosser II* is the high-sex image of teen-boy desire. The cross-bike racer is a toy posed on top of a book. Patterson plays with the idea of how the mind reads action in a still image. The illusion of the biker's movement is given only through the vibrant colours of the paint, while other details add a surreal element – the puddle of water is solidly still. This illusion is complex: before Patterson made this painting, he coated the toy itself with high-energy brush marks. He then photographed the scene, and made a painting of the photograph. The end result is a speed racer which looks freakishly static, racing through an out-of-focus background which seems oddly reminiscent of a giant blow-up detail of a Kandinsky painting.

80 Culture Station #2 – Dirty Picture

Images overlap each other in skewed grid form, each one a celebration of painting within itself: hyper-real girl in bikini, taken from a sixties motorcycle ad, flashes between still lifes of canvases in the artist's studio, segments of an abstract painting and a 'snapshot' arm blurred as if through a moving camera lens. Mounted on separate canvases, a painting starting in one place is interrupted by another and continues on somewhere else out of context. It's possible to reorder the image: for Patterson there is no such thing as a perfect composition. *Dirty Picture* gives the illusion of time, space and action running off the canvas, incorporating everything around it into an endless narrative.

DEXTER DALWOOD

Dalwood makes paintings of famous places he's never seen – *Camp David*, *Che Guevara's Mountain Hideaway*, *Sharon Tate's House*, unviewed museums of a collective conscious. Dalwood gets into the mind of his subjects and rebuilds their psyches with conviction by imagining the details of their environments. Dalwood also uses the 'image' of paint to give clues of time and space, 'shoplifting' various images and styles from other artists' paintings which conceptually relate to his own. It's through the medium that Dalwood's paintings achieve impressive authority: each object individually rendered in a language of its own – the startling variation of texture and surface treatments, the connectedness between gesture, colour and subject. Dalwood isn't simply representing possible images; he's building their architecture in real time. Dalwood's visions become actual landmarks unto themselves.

81 Kurt Cobain's Greenhouse

It's hard to identify this urban-perfect scene as the suicide site of a grunge god; only the idle guitar and empty chair tell that someone's not there. Dalwood imagines his scenes with the up-close-impersonal sterility of *Hello!* magazine spotlights; everything needed to know about the person is in the paint. As in Magritte's *Empire of Light*, *Kurt Cobain's Greenhouse* is both day and night; a lot of time has been spent contemplating in this room. Bright-lights big-city success blares

in the distance, and the boughs in bloom offer unattainable promise on the other side of the glass; while inside there's only a corroded pipe and pathetic box of posies to signify trampled self-esteem. Dalwood's painting is an allegorical fallacy of heroism.

82 Jackie Onassis

In his painting of Jackie Onassis's infamous Mediterranean yacht retreat, Dalwood has captured the time in a single glance: the over-designed black lacquer tables, the hideous Florida chintz sofa, neo-deco lamps and waterbed. Andy Warhol's diamond-dust painting, *Shoes (Magnin)*, on the wall stamps it with an exact date: 1980. All as perfectly fashionable as Jackie O herself. It's only the resounding hollowness of this scene which gives way to thoughts of a tragic heroine: surrounded by all the luxuries money can buy, her only real solace comes from a simple sunset, which she can watch for hours, dreaming away her grief.

83 The Queen's Bedroom

Working from a courtroom transcription of a burglar's account of the royal boudoir, Dalwood paints a lonely depiction of the Queen. In a Spartan retreat in Union Jack colours, ERII lives only for her country. The blinds are drawn, sealing out the real world she's unable to participate in. The tiny bed excludes any kind of relations with Philip; there's just a portrait of a long-dead relative for company. The only cosy attribute is a small electric space heater to keep her miserly bones from aching. Only Dalwood could dream up a Queen too tight to pay the gas bill. Even though this painting is an invention, there's an overwhelming sensation that it's more than likely true.

MARTIN MALONEY

Maloney makes social observation paintings, trendy and casual, like jeans ads, or thirty-something sitcoms. His anecdotal scenes are contemporary adaptations of the type of genre paintings, still lifes and portraits seen in historical paintings from artists such as Poussin, Vermeer, and Watteau. Manor homes and pleasure gardens are updated to discos, parks and sex clubs; ballgowns and long coats are swapped for high-street fashions. Painting versions of people he's seen on the street, in his neighbourhood, in his grocery store, Maloney places them in delightful pastoral situations which both mirror and lovingly mock *en vogue* circumstance and fancy. His messy painting style is comically accurate, his figures are all too familiar, each one with an imagined personality and history completely unique to them.

84 Rave (After Poussin's *Triumph of Pan*)

Rave is a contemporary version of the seventeenth-century painting, borrowing both subject and composition. Transforming the master's racy orgy scene (women, men, goats going for it under the hypnotic influence of horn music – painted with the very epitome of tasteful credential), Maloney's vision of a wild club night of Y-front-pantied dancers, and casual snogging seems positively tame. His intentional

casual painting style transforms classic mythological high art into a tangible, intimately concerning scene for today.

85 Equal Opportunities

Inspired by a newspaper photo of A-level students and their teacher on the day of their results, this is a classic coming-of-age story. Maloney conveys their hopeful triumph through a certain abstraction. Attracted to the gridlike composition, he pushes the bounds of what can be recognisable in a naturalist painting: a yellow-and-black mass transforms into home-styled dye job, purple scrawls stand in for hands, a green square with red dots becomes a frock. Looking closely at painters like Baselitz and de Kooning, Maloney pays careful attention to rendering clothing patterns and facial expression – mouths, eyes, make-up –giving each figure a believable and sympathetic personality of their own.

86 Slade Gardens SW9, 1995

With his first foray into large-scale collage, Moloney replicates painting with thousands of individual pieces cut from coloured sticky-backed vinyl. He shares the secret of paint: a large pink mass for a face, a splotch of white and a line of yellow for a highlight, two semicircles of blue for eyeshadow. Loads of little stringy bits clumped together make a shaggy dog. This leisurely day in the park just isn't as easy as it looks: this process is as intricate and labour intensive as assembling a Ravenna mosaic.

87 Hey Good Looking (After Poussin's *The Choice of Hercules*)

Maloney's Hercules is one hot stud: Rod Stewart hair, chest merkin and red Speedos. Like in Poussin's allegory, he's pulled two birds, Vice and Virtue, and now has to make a choice. He's already in like Flynn with Vice: a hot-tomato single mum with Christina Aguilera's taste in clothes. But his eyes are leaning towards the Olivia Newton-John goody-goody – she's gonna be no easy task. It's Maloney's contemporary twists that make this painting especially funny: Poussin's finely rendered drapery is substituted with a beach towel, Vice's sweet cherub's transformed into a latchkey brat. A little divine romance for the high street.

CECILY BROWN

Brown paints the impression of pornography. It isn't the painting version of girl-on-girl blue movies showing a male idea of female desire; Brown re-creates the come-hither seduction of women's psychology. This is sex from a woman's perspective: fun, erotic, sophisticated and clever. Participating in a traditionally male activity of abstract painting, Brown's work is marked by a female affinity for the medium, a feminine physicality in the application, colours, and surface. Turning the tables of art history, she's like one of de Kooning's ravaged women taking sweet revenge.

88 High Society
This reads like an F. Scott Fitzgerald orgy: little men in top hats and tails, muscle-bound millionaire hunks pulling themselves to climax, indiscernible bits of sensuous bodies, detached penises, the allusion of gossipy dinner-party crowds. Set against a lavish gold-and-blue background, Brown's fantasy is a rich girl's predilection. A notch on her bedpost for Cézanne and early Pollock.

89 Pyjama Game
Named after the Doris Day film, this *Pyjama Game* has no intention of maintaining a squeaky clean image. Brown's painting has all the fun of a screwball comedy. Delightfully innocent and sophisticated at the same time, a plot laid out in abstract: mistaken identity, sexual innuendo and glamorous design in 1950s red.

90 The Girl Who Had Everything
Done in the fleshiest of pinks, ripe for the taking, this painting has a smug satisfaction; it is populated with fragments of figures as twisted and mysterious as those of a Francis Bacon.

91 Night Passage
Possessing all the vigour of macho abstraction, with the pastel decorative palette of Monet's water lilies, and a girlie reference to Georgia O'Keeffe, *Night Passge* creates the impression of a couple copulating.

MICHAEL RAEDECKER
Michael Raedecker's early paintings of American-style dream homes nestled into majestic landscapes offer a stillborn promise. They are images of an immaculate utopia, tinged by a surreal nostalgia, an expectant sense of waiting. Part of Raedecker's eerie aesthetic comes from his use of stitching in conjunction with paint. For Raedecker, thread is just an extension of paint: another tool to achieve an illusionary sense of texture, depth, shape and colour. A tangled ball of green yarn can represent a tree or a bush, in the same way that one or two lines of fine glossy thread can be a sun beam reflecting off a dirty window.

92 Beam
Raedecker is a big fan of film, especially anything with grandiose American landscape, the untamed freedom of the west. In *Beam*, he paints a lonely cabin in the woods – but this is no ordinary night scene: it's almost like the painting has been solarised. A strange halo glow radiates from the trees, the crackling surface of the ground flickers between positive and negative light like an unnatural frost effect. There are shadows everywhere, distinctly pronounced in a conscious mirroring of the image: a double painting in one. This is a scene which is impossible in nature, but completely commonplace in Raedecker's imagination. And in spaghetti westerns. Raedecker got the idea from night scenes in old cowboy flicks, which were shot in the daytime with a filter over the lens.

93 Ins and Outs
Steely grey in the dead of night, manicured in the expansive landscape, trees in a straight line, boulders placed decoratively for maximum effect: it's maybe the retirement retreat of a Silicon Valley millionaire. The kind of person who would trouble to prune their trees into perfect orbs, who'd insist that their sky be as delicate as a Japanese watercolour. Raedecker's paintings are always little seeds of gossip. Drawn to this house by the impossible intensity of the light – made up of countless tiny pink and yellow threads – the first instinct is that something suspicious is happening within.

GRAYSON PERRY
Perry makes ceramic pots, hand-stitched quilts and outrageous dress designs, creating a cosmopolitan folk art. Melding handicraft and consumer culture, his objects are luxury one-of-a-kinds with a Rodeo Drive chic. Perry's urns are rendered with an incomprehensible mastercraft: their surfaces richly textured from designs marked into the clay, followed by intricately complicated glazing and photo-transfer techniques. His form and content are always incongruous: classic Grecian-like urns bearing friezes of car wrecks, cellphones, supermodels, as well as darker, more literary scenes often incorporating autobiographical references.

94 We've Found The Body Of Your Child
This has the preciousness of a well-travelled Russian antique. Glazed in golds, silvers and whites, Perry's urn tells a Gothic tale of a child's death in a gloomy small town. The image is timeless: it could be yesterday or eighty years ago; but almost certainly it has to be Eastern European – nowhere else could such horrific grief be met with such fairy-tale romanticism.

95 Golden Ghosts
Inspired by Perry's experiences as a transvestite, his 'little girl' vases hint at-an autobiographical referencing: his penchant for wearing baby-doll dresses, the questions of male role models and the development of his sexuality in his childhood. For Perry, this is an expression of an unrecoverable lost innocence. Pastiched with delft images of ladies-in-waiting, delicate flowers, teddy bears and embossed tear-drop patterns, Perry's work offers a hallowed place where unhappy souls exist as golden shadows of the children they never got to be.

TIM NOBLE AND SUE WEBSTER
Tim Noble and Sue Webster live in a self-styled world of bravado. Best known for their self-portraits, Noble and Webster sculpt themselves as Neanderthals, collage their heads on to the covers of trendy magazines, and make shadow projections cast from garbage heaps, dead animals and money. In their shadow sculptures, Noble and Webster present themselves as what they embody: trash and cash is the substance, but beauty always lingers delicately nearby. Noble and

Webster manufacture an image for themselves based on rock-star-infused dreams, but it's a fantasy fuelled by a streetwise despair. Noble and Webster's shadow works are something of a science. As sculptures, these pieces are simply a lot of garbage stuck together. But turn the gallery lights off, and aim a precision-placed spotlight at them, and the most amazing shadows appear on the wall. It's this incongruous blend of trash culture and unabashed romanticism which captures the tender side of Noble and Webster's punkish attitude.

72 Toxic Schizophrenia

Noble and Webster's electric drawings are livin'-large images, such as champagne fountains, dollar signs and logoistic slogans, e.g, Forever, L–ve and VagueUs. A repertoire of too-cool-to-care iconography. *Toxic Schizophrenia* is a classic badass tattoo, constructed from 516 little lightbulbs. Blaring violently bright and self-indulgent, Noble and Webster's piece takes pop art to the extreme, blowing it up in lights like fly-by-night casino chintz. The artists design and make these light paintings themselves, creating a DIY glam that's better than the real thing.

96 Miss Understood & Mr Meanor

Here Noble and Webster portray themselves with a faux-medieval brutality: severed impaled heads with all the requisite gore. The dripping-blood effect is the oozing residue of a glue gun – the messy remnants of a precision craft. This isn't the terrible-teen expressionism of the Chapmans, however. Noble is teasingly sticking his tongue out at Webster in a joke shared between friends.

97 The Undesirables

A mountainous rubbish heap is transformed into an epic scene of the couple on a lonesome clifftop, quietly sharing a fag. A carefully placed smoke machine provides the tiny wisps of smoke smouldering from Webster's cigarette; oscillating fans wave the grasses in a subtle breeze. Noble and Webster present a degenerate craftwork diorama of traditional values of love and togetherness, a you-and-me-against-the-world determination.

PETER DAVIES

Davies's text paintings combine 'the tough, dry humour of conceptualism and the elegance and beauty of formalism'. As Davies explains: 'It allows conceptualism to be a "look" and formalism to be an "idea".' Davies paints transient pop-cultural information systems – lists, charts, bylines – in the slick, clean, high-art tradition of minimalist painting. As in Davies's abstract works – which are often mega-sized canvases filled with imperfect patterns of bright colours – his aim is to bring the sterile stereotypes of modernism down to a user-friendly level. In his text paintings, Davies uses paint, language and structure to talk about art as if it were just another commodity in the entertainment business; by doing so he places himself at its forefront.

98 Text Painting (Art I Like)

Completely filling a canvas with tiny scrawl, this painting has the effect of textured colour field, made up of every colour. It's a grand gesture to a grand era of academic text art, intended to subvert its grand ideas about art and theory. Showing off his cosmopolitan understanding of art history, Davies's *Text Painting* tries its best for an easygoing aesthetic; the text itself is an outrageous rant, 'cred-ing' or 'diss-ing' art gods in the language of youth culture. 'Louise Bourgeois tough tits she'll rip you to bits', 'Antony Caro now he really is one badass MF SOB', 'Luc Tuymans now I wouldn't want to meet him down a dark alley'. Davies takes on the whole of art history and comes out on top.

99 Fun With The Animals: Joseph Beuys Text Painting

In a giant incomprehensible flow chart (a form borrowed from Beuys's blackboard works), he maps out the 'six degrees of separation' of his art heroes, linking them impossibly to each other, and inevitably back to Beuys. It requires the complicated linear thinking of a late-night drinking game, but Davies proves it's only twelve easy jumps from Picasso to Sarah Lucas (if Peter Doig and Matthew Barney's love of sport can be counted as an actual link). Davies presents an art history on a functional level: it's about as close to science as it gets.

100 The Hip One Hundred

Taste is identity: Davies is as hip as his *Hip One Hundred*. As frivolous as late-night Top 100 TV shows, Davies's painting is even more fun to watch, and even more entertaining to argue with (Jeff Koons only comes in at 56 – as if!). Rating his friends, colleagues and art heroes, Davies pits artists and their works against each other in his mind, vying with each other for that coveted number-one spot. Davies exposes an art world as insidious, cliquey, market-oriented as any entertainment medium. By making this painting on grand scale, he's created a high-art monument to the undoing of sacred high-art values.

99 PETER DAVIES, FUN WITH THE ANIMALS:
 JOSEPH BEUYS TEXT PAINTING, 1998
 acrylic on canvas, 396.2 x 243.8cm (156 x 96in)

1	RICHARD PATTERSON	Dirty Picture - Culture Station
2	FELIX GONZALEZ-TORRES	Art for distribution - Lights - dancing - Pap
3	SEAN LANDERS	Text
4	ALEX KATZ	'Red Smile'
5	CHARLES RAY	The Most beautiful Woman in the Worl
6	DAMIEN HIRST	1000 Years
7	ELLEN GALLAGHER	Slightly Agnes Martin with personality the
8	JOHN CURRIN	Big Tits + beardy blokes
9	BRUCE NAUMAN	Double NO
10	LAURA OWENS	View through herown Museum door
11	SARAH MORRIS	'SHIT'
12	JASPER JOHNS	Flag
13	SIGMAR POLKE	Higher Powers
14	RICHARD PRINCE	Cowboys and Biker G
15	ASHLEY BICKERTON	Crucifixion + the Colle
16	ELIZABETH PEYTON	Kurt + Liam
17	FRANCIS PICABIA	Late 'BAD' Paintings
18	MARTIN KIPPENBERGER	Punk rock attitude
19	CARROLL DUNHAM	semi-abstract funky monster mutant +
20	KAREN KILIMNIK	Kate Moss + Princess Di
21	THOMAS RUFF	stark headon Portraits
22	HENRI MATISSE	Red studio
23	WOLFGANG TILLMANS	Photos + wall collage installation tec
24	FRANK STELLA	shaped canvases
25	DAVID SALLE	Recent Rosenquist 'inspired' pain
26	FIONA RAE	TOMB RAIDER
27	C + I HOHENBUCHLER	Post Bauhaus Folksy craft ef
28	CHRIS OFILI	Afrodizzia / Captain su
29	LARRY CLARK	drugs, guns + teen sex
30	RACHEL WHITEREAD	Venice - tables + bookshel
31	TOBA KHEDOORI	Huge paper pictures of windows + st
32	CHRISTIAN SCHUMANN	90's blend of text, image, collage + struc
33	PIERO MANZONI	Tins of shit
34	RITA ACKERMANN	Pre-Pubescent Girls in hazy seedy fantasy

100 PETER DAVIES,
 THE HIP ONE HUNDRED, 1997
 acrylic on canvas, 254 x 203.2cm
 (100 x 80in)

E HIP ONE HUNDRED

LBERT+GEORGE	'Complete Arseholes'
NDREAS GURSKY	Banks, Stock Exchanges, Tower blocks, Ski resorts
LY VAN DER STOKKER	Funky Corner Wall drawings
CHARD BILLINGHAM	Mum with Cat + Syringe
UE WILLIAMS	New sort of all over rewriting paintings
EFF WALL	Nose bleed
EAN-MICHEL BASQUIAT	PEGABUS
EKSANDR RODCHENKO	Pure Colours: Red, Yellow + Blue
HRIS BURDEN	Nailed to V.W. Beetle
HARLES LONG	for collaborating with STEREOLAB!
NDY WARHOL	Films
ARLENE DUMAS	Watercolours (weird) of Models + children
OSEPH BEUYS	Blackboards — Flowcharts
AN GOLDIN	Snaps of Transvestites
ORDON MATTA-CLARK	Cutting buildings in two
IM SHAW	Thrift store show
ICHARD PHILLIPS	Realist 70's female model paintings
LLIAN WEARING	Dancing in Peckham, Signs + Lip Synching
IJA CELMINS	Sea
st formerly ART CLUB 2000	for changing their name to AC2K.
ERND+HILLA BECHER	Water towers
EFF KOONS	Giant flower power puppy
HOMAS SCHUTTE	Big shiny Michelin Men metal figures
ANAGAN/KELLEY/McCARTHY	Collaborative works !!!!
AMMOND PETTIBON	Angry cartoon style
ATHERINE OPIE	Photos of Butch Dykes
ARAH LUCAS	Middle finger
REY WINTERS	Ugly/Beautiful latest abstract paintings
HN BALDESSARI	I am making Art
UANE HANSON	superreal white trash figures
OBUYOSHI ARAKI	Japanese SM/Bondage teenage girls
ICHARD SERRA	Torqued Elipses

67	JASON FOX	Paintings on sleeping bags
68	MARTIN HONERT	Bonfire + child at table
69	ANDREA ZITTEL	A-Z living
70	GARY HUME	Francis (Bacon)
71	BRIDGET RILEY	Op Art
72	STEPHAN BALKENHOL	Hand Carved gothic wood figures
73	MICHAEL CRAIG-MARTIN	Paintings featuring style classics
74	ALEXIS ROCKMAN	Sewage Paintings
75	LARI PITTMAN	Large scale cacophonies of red light text + images
76	VANESSA BEECROFT	Ein Blonder Traum
77	CINDY SHERMAN	Untitled Film Stills
78	JACQUELINE HUMPHRIES	Pulp fiction process painting
79	RINEKE DIJKSTRA	After Botticelli Teenagers on Euro beaches
80	KARA WALKER	silhouette black history cut-outs
81	SYLVIE FLEURY	designer store carrier bags
82	JESSICA STOCKHOLDER	crazy colourful cut up wall pile ups
83	GIORGIO DE CHIRICO	Quirky collaged compositions
84	JANINE ANTONI	Mom+Dad Sex change makeovers
85	MARTIN MALONEY	Post Poussin figure — FESTS
86	SOPHIE CALLE	Suite Venitienne
87	JOHN COPLANS	Tough self-portrait body insections photos
88	JASON MARTIN	Shiny silver/chrome one
89	ELKE KRYSTUFEK	Masturbation performance
90	RON MUECK	Dead Dad
91	TOBIAS REHBERGER	Stylish retro furniture
92	HIROSHI SUGIMOTO	Chamber of Horrors
93	PIPILOTTI RIST	Big furniture + Trashy Pop Promo style videos
94	ALEX BAG	Damien Hirst spoof film
95	CLAY KETTER	Fitted Kitchens
96	JASON RHOADES	Post scatter junk installations
97	KCHO	Tatlin Tower rip off
98	ANNIKA VON HAUSSWOLF	Bubble Gum
99	MATTHEW BARNEY	Fight in Limo
100	CARSTEN HOLLER	Child Tormentation Film

Published by Jonathan Cape in association with The Saatchi Gallery 2003

10 9 8 7 6 5 4 3 2 1

First published in Great Britain in 2003 by Jonathan Cape, Random House,
20 Vauxhall Bridge Road, London SW1V 2SA in association with The Saatchi Gallery

The Random House Group Limited Reg. No. 954009
www.randomhouse.co.uk

A CIP catalogue record for this book is available from the British Library

ISBN 0-224-071807

Edited and Designed by Mark Holborn
Production Controller: Simon Rhodes
Printed in Germany by Appl Druck, Wemding

Boards: Detail from Damien Hirst,
Argininosuccinic Acid, 1995

Endpapers: Detail from Damien Hirst
Untitled, 1996